POSTCARD HISTORY SERIES

Oak Park

IN VINTAGE POSTCARDS

D1411368

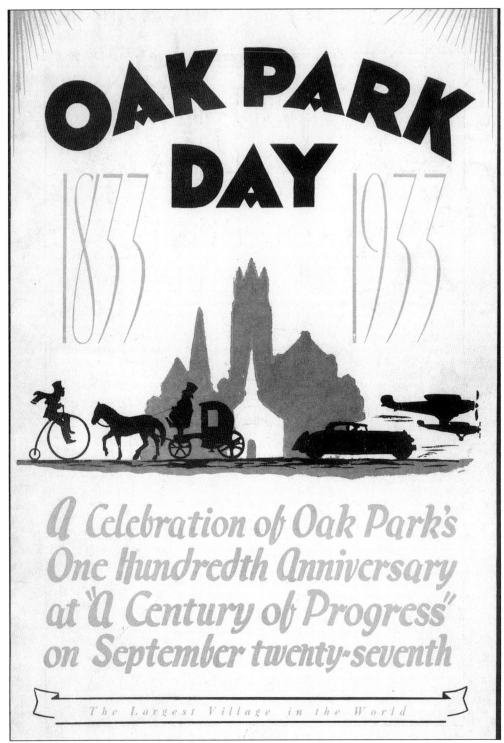

Large-scale pageants and parades were featured during the special Oak Park Day celebration held at the "Century of Progress" World's Fair in Chicago on September 27, 1933.

POSTCARD HISTORY SERIES

Oak Park

IN VINTAGE POSTCARDS

Douglas Deuchler

ARCADIA

Published by Arcadia Publishing,
an imprint of Tempus Publishing, Inc.
Charleston SC, Chicago, Portsmouth NH,
San Francisco

Printed in Great Britain.

Library of Congress Catalog Card Number: 2003107198

For all general information contact Arcadia Publishing at:
Telephone 843-853-2070
Fax 843-853-0044
E-Mail sales@arcadiapublishing.com
For customer service and orders:
Toll-Free 1-888-313-2665

Visit us on the internet at http://www.arcadiapublishing.com

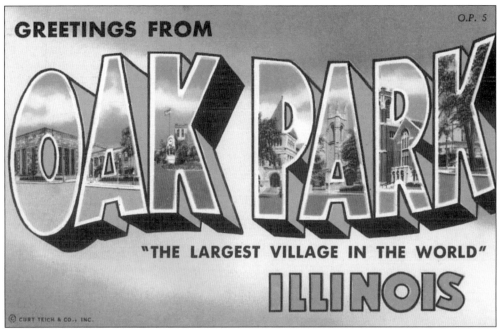

Highly popular in the 1940s, "large letter postcards" from the Curt Teich Company featured a tiny scenic view within oversized capital letters that spelled the name of a geographic location.

CONTENTS

ACKNOWLEDGMENTS

The bulk of the postcards included in the following pages are from the archives of The Historical Society of Oak Park and River Forest and the personal collection of board member Joe May. This book would not have been possible without the generous help and guidance of a number of people. I would like to extend my grateful appreciation to each of them:

To Frank Lipo, Executive Director of The Historical Society of Oak Park and River Forest, for his keen insights and editorial skills, and Diane Hansen, research assistant, for always sharing in the excitement that comes with historical "digging";

To Joe May, enthusiastic deltiologist, who knows the tricks of the postcard trade, including how to date images by their serial numbers;

To James N. Walsh, a former Oak Parker now living in California, who generously presented the historical society with a large collection of Oak Park postcards;

To Elsie Jacobsen, who early on got me hooked on the history of Oak Park;

To Don Vogel, information services division head and "keeper of the archives" at Oak Park and River Forest High School, for sharing several postcard treasures;

To the curators of the Lake County (IL) Discovery Museum, Curt Teich Postcard Archives, for permission to use a number of wonderful Teich images of Oak Park;

To Marcia Palazzolo for supplying "snapshot postals" of her family members.

To architect Randolph C. Henning of North Carolina for sending in several images we'd never seen before, including the postcard on the cover;

To Bob Glass for loaning some additional rarely-seen views;

To the many anonymous postcard photographers of yesteryear who presumably had no idea that their work would someday be appreciated as art and history;

To Samantha Gleisten, my editor, for her generous guidance and enthusiasm;

To my wife, Nancy Deuchler, for her on-going support and loving encouragement.

A heartfelt thank you to one and all!

INTRODUCTION

Postcard sales were big business in the early 20th century. In fact, by 1909 Americans were buying more than one billion postcards a year.

Today, of course, we think of writing postcards as strictly a vacation ritual. We jot a few lines on the backs of scenic views to brag about our trip while we show friends and family they're not forgotten.

Picture postcards were used quite differently in the early 1900s, however. Cheap, efficient, and relatively speedy, they were the e-mail of their day.

A penny postcard cost only another cent to mail. Many households still did not have a telephone. But since mail was sorted at all times and there were several deliveries per day, a postcard might arrive within a couple hours after it was sent.

Postcards could provide a quick hello, a birthday greeting, or a get-well-soon. Often they acknowledged a letter was received ("Will write soon!").

Travelers documented their progress, such as when changing trains or altering their routes. People made inquiries, such as "May I borrow your dotted Swiss for Mabel's party?" (1924), or passed along mundane bits of information:

"The X marks our room, right above the Lobby." (1933)

"Caught last train—arrived home safely." (1912)

"Baby sick with croup. Don't count on Floyd and me for dinner Sunday." (1924)

"Still looking for work. Suspect some in a few days. Will telephone soon." (1931)

"Don't forget to bring Aunt Stella & her sweet pickles to the picnic." (1914)

Penny postals often provided voyeuristic pleasure to "postcard snoops" glancing at the correspondence scribbled on the backs of the scenic views. Even now, those few lines can yield an irresistible glimpse into long-ago lifestyles and relationships. Ida to Charles (1909): "Yes, I received the pearls but lo, I have to get the monkey wrench every time I wear them. Nevertheless, hurry home, honey! All parties are at a standstill in Oak Park till you return."

Itinerant jobbers kept merchants supplied with so many varieties of postcards, there were often multiple images of the more popular local sights. Many homes and neighborhoods were depicted on a number of scenic views.

Postcards became so popular by 1909 that a major fad that year was the "postcard shower." Arranged by the bride's girlfriends, such a gathering could net the recipient at least 200 new postcards.

Families dutifully collected the postcards they received. They proudly displayed hefty postcard albums on their Mission-style parlor tables.

The volume you hold in your hands, in fact, is quite similar. It's a veritable scrapbook crammed with 236 historic postcard images from 50 to 100 years ago.

In addition to the quaint charm and artistic beauty of a period postcard view, each old-time image can also function as a virtual time machine, transporting us back to a seemingly less hectic, more picturesque era.

While no individual work can tell the full story of a community's history, this collection of vintage views provides a unique tour through Oak Park, Illinois—the world's largest village—during the golden age of the picture postcard, from the 1900s through the 1950s.

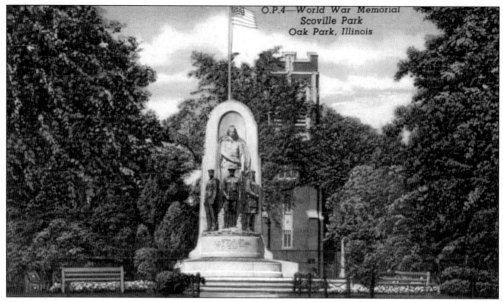

In 1925, Oak Park sculptor Gilbert Riswold created the World War I Memorial. Bronze statues representing the U.S. Army, Navy, and Air Force guard the heroic granite figure of Columbia in Scoville Park.

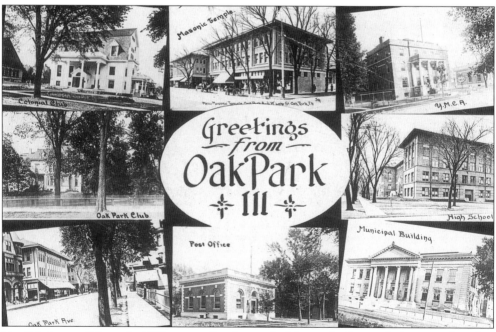

Candid photos of the early 1900s were often jammed with people. Postcard views, on the other hand, were usually photographed just after dawn, before streets were crowded with wagons, autos, or pedestrians.

One
WISH YOU WERE HERE

Oak Parkers of the early 1900s took great pride in their village. They especially loved sending friends and family members picture postcards of their favorite buildings and local landmarks.

Drug stores provided revolving racks to allow customers to wait on themselves. People could choose from scores of different village views. Often there were multiple images of the most popular locations, such as the Scoville Institute, the new YMCA, Municipal Hall, millionaire John Farson's mansion, or curvy, picturesque Elizabeth Court.

Judging by the hundreds of old-time Oak Park postcards that are now highly prized by collectors, one might assume the village must have enjoyed status as a major tourist attraction. But the truth is simply that although tourism thrives today in Oak Park, such was not the case in the early 20th century. People simply just wrote an awful lot of postcards!

About 1908, the Eastman Kodak Company began selling postcard-size photographic paper with divided backs. Drug stores could now offer their customers a popular new film-processing alternative. Anyone with a Kodak Brownie camera could have their candid photos printed as postcards directly from their negatives.

All you had to do was "snap" the shutter. "Snapshot" postcards, as they came to be called, made possible a fun new kind of informal family portrait. Nearly a century later, these real photo images provide us with a delightful glimpse at the look and lifestyles of long-ago Oak Park.

Though Oak Park is internationally known as the birthplace of the Prairie School of architecture popularized by Frank Lloyd Wright and his colleagues, the majority of new buildings being erected in the village a century ago employed historic styles of architecture, as seen in this 1905 postcard.

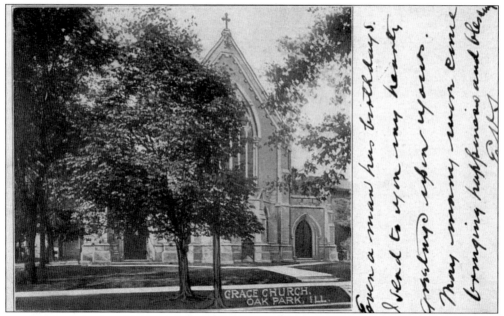

Until 1907, only the address was permitted on the backside, which accounts for the distracting correspondence often found on the picture side of early postcards. This view of Grace Church was used as a birthday card.

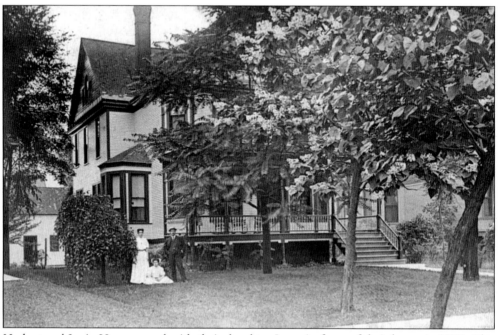

Herbert and Jessie Hewes posed with their daughter Irene in front of their home in 1907. This house is still standing at 215 South Scoville Avenue.

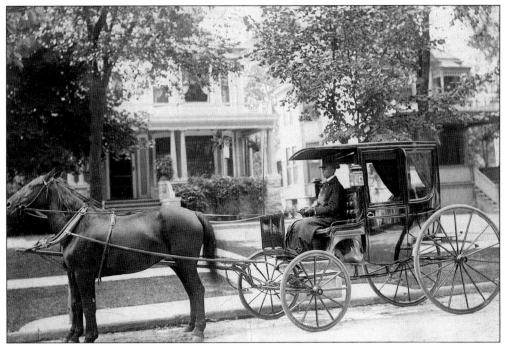

The coachman is Brook Thomas. The large porch is gone and the entrance has been altered but the residence still exists at 327 Home Avenue.

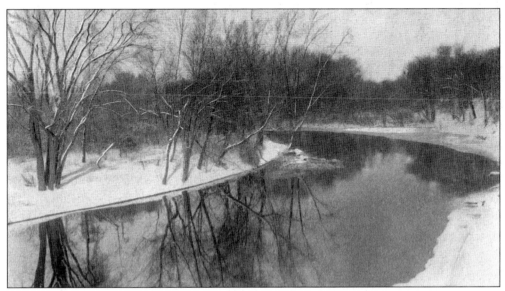

The nearby Des Plaines River, a main transportation route for the indigenous Native Americans until the 1830s, was especially picturesque during the winter. In the 1900s, skating parties were popular among young Oak Parkers.

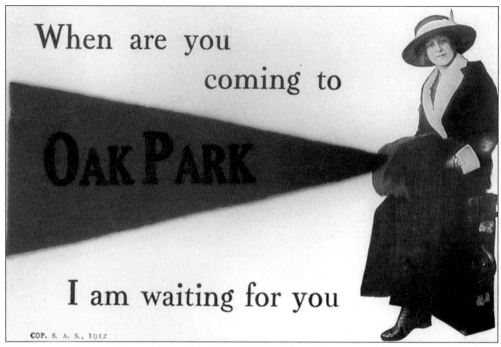

Many postcards were "boosters" for the village. This 1912 card has an actual felt pennant glued on.

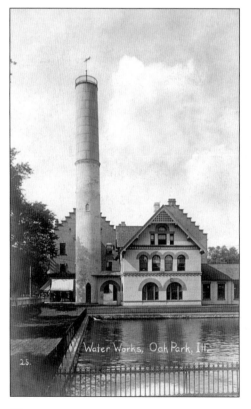

The Water Works and Power Company on the east side of Oak Park Avenue just north of North Boulevard had a 68-foot tower and a reservoir of 27,000 gallons that supplied water to most of Oak Park. After 1917, water was piped in from Lake Michigan.

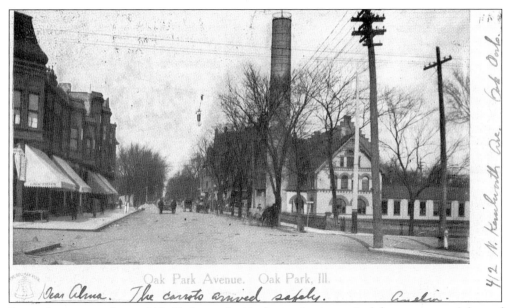

Oak Park Avenue. Oak Park, Ill.

Dear Alma. The carrots arrived safely. *Amelia.*

Postcard messages, often scribbled below or beside the scenic view, suited the new century's love of speed and convenience. Postcards functioned like e-mail, providing a quick greeting or a mundane exchange of information, such as Amelia informing Alma her "carrots arrived safely." (1907)

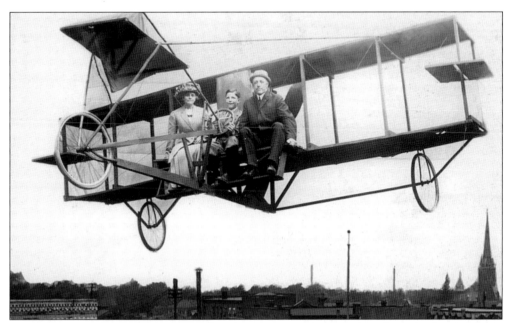

Aviation was in its infancy in 1909 when this studio-made gag postcard was made of W.W.S. and Leola Carpenter and son in their "flying machine." The Carpenters lived at 210 South Elmwood Avenue.

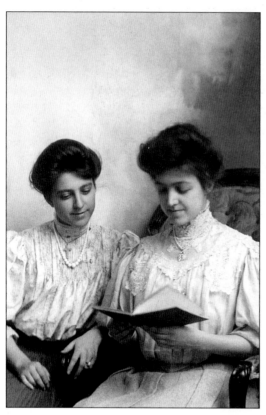

Shirtwaist blouses were in vogue when this postcard of the married Seabury sisters of Oak Park, Hazel Cotsworth and Roxanne Wright, was mailed in 1911. In New York's Lower East Side that year, 146 young seamstresses died in a sweatshop fire at the Triangle Shirtwaist Factory.

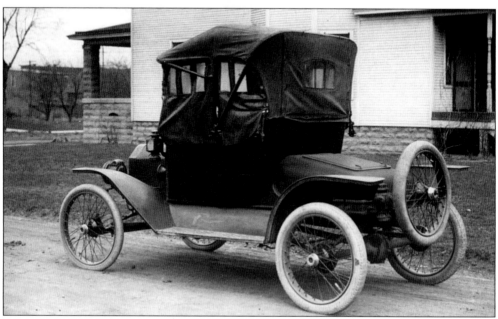

Each year, automobiles became easier to drive and maintain, as well as faster and cheaper. As more families acquired cars, Kodak "snapshot" postcards were mailed to friends to document their new status-altering prized possession, such as this 1914 Model T Ford roadster.

307.
Kenilworth
Avenue,
Oak Park,
Ill.

Papa says you are collecting postals and I thot this was a pretty one. I will send you more. With love Irene K.

nov 29–06

Though the messages written on the face of early postcards tend to distract, they often provide insight into the lifestyles and sentiments of the era.

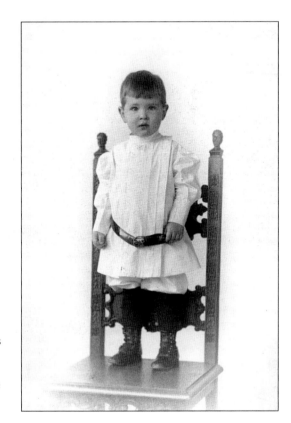

While views of local landmarks were widely sold, personalized photo postcards made in Oak Park homes by itinerant photographers became increasingly popular as well. This is Charles Gale, age two, in 1908.

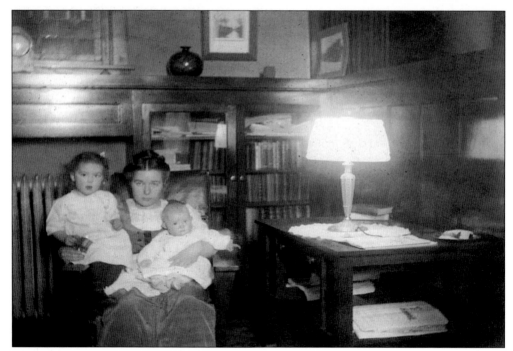

This 1914 "snapshot" postcard shows the art glass windows, built-in bookcases, and heavy Mission style furniture treasured by early-20th-century Oak Park families. Marie Kirby holds daughters Betty and Marion at 600 North Lombard Avenue.

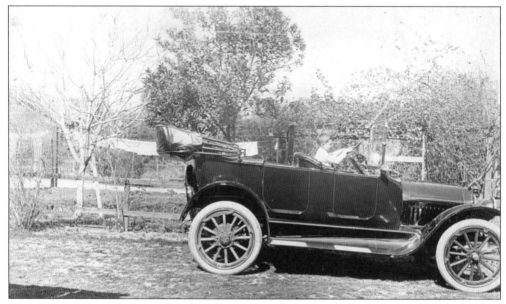

Seven-year-old Charles Gale is pretending to drive his family's new 1914 automobile.

Though it looks dubious to us today, this 1913 vacuum cleaner was thought to be an efficient, labor-saving device.

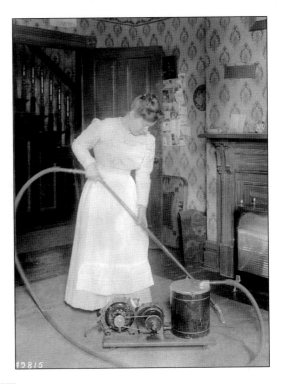

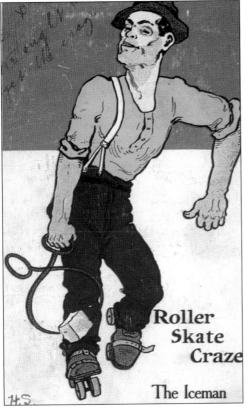

A well-equipped Oak Park kitchen contained an icebox, frequently located on an outside wall so the ice-delivery man could deposit fresh ice into the box from the back porch without entering the kitchen. Roller skating was a fad when this comic postcard was mailed in 1908.

Proud new Oak Park home-owners often had postcards made of their residences, such as these two 1910 views depicting the four-square-style home at 535 North Elmwood Avenue in different seasons.

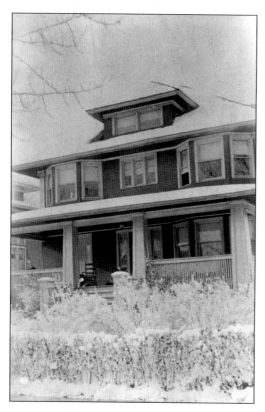

A four-square house had a pyramidal roof, second floor bay windows, and a broad front porch that ran the full width of the first story.

People of the early 20th century are sometimes perceived as stuffy and upright. Yet these postcards mailed in 1911 (above) and 1908 (below) reveal Oak Parkers of that era were not without their playful, even naughty streak.

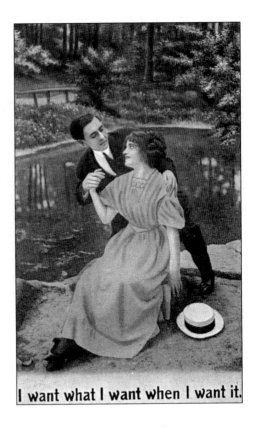

I want what I want when I want it.

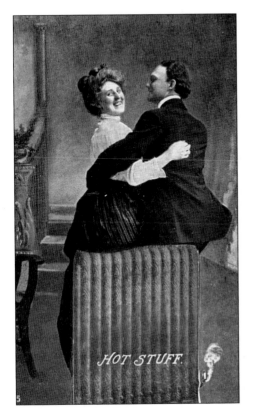

HOT STUFF.

Although Frank Lloyd Wright thought radiators so unsightly he masked them with built-in coverings, most people were thrilled with this clean, efficient modern method of heating their homes.

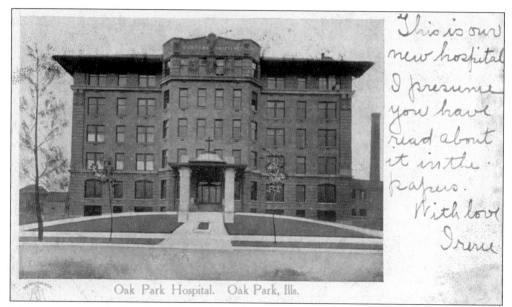

The message scrawled on the right of this 1907 view emphasizes the importance of Oak Park's first hospital. "Dropping someone a line" via postcard was a quick, popular way to stay in touch with loved ones.

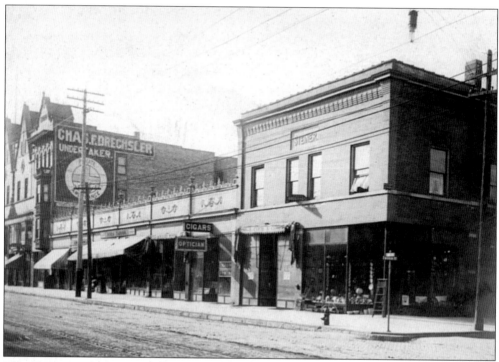

This 1909 view shows the northwest corner of Lake and Marion Streets. Note the tall Drechsler Undertaking building to the left. The Steiner building on the right corner was torn down in 1928 and replaced with a department store called the Fair. Now it's Barbara's Bookstore.

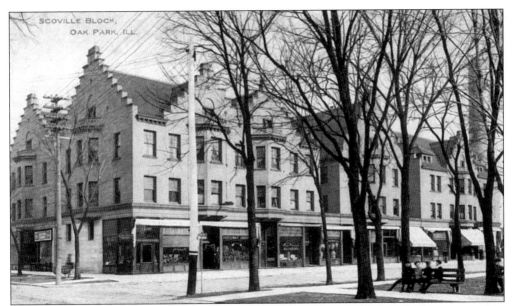

This 1907 view shows the Scoville Block, 116-136 North Oak Park Avenue, constructed in 1899. This three-story complex of stores and flats was inspired by the town hall in Frankfort, Germany, which developer Charles Burton Scoville had admired on postcards. Key features were the steep Flemish gables, the tile roof, and the projecting bays. Soon E.E. Roberts' Masonic Block, also commissioned by the Scoville family, would be built where the men are sitting on the bench across the street.

The towering steeples of many early churches in the village earned Oak Park the nickname "Saints' Rest." But these spires also functioned as lightning rods, causing many disastrous fires. First Congregational, seen here to the left of the Scoville Institute, was hit with lightning and burned in 1916. This 1907 view from Kenilworth Avenue looks east on Lake Street.

Sidewalks were made of planks when much of north Oak Park was deeply wooded and undeveloped, as seen in this view of Forest Avenue in 1907.

In the early years of the 20th century, many newcomers were attracted to Oak Park not only by its good schools and convenient transportation but also the woodsy, country feeling of its neighborhoods.

Before TV and air-conditioning, people really knew their neighbors. Most Oak Parkers spent summer evenings sitting on their wide front porches. This postcard is postmarked 1908.

Three sisters, Helen, Marion, and Betty Kirby, posed on their porch, 600 North Lombard, in the summer of 1915 with their Grandpa James Kirby, a Civil War veteran whose left arm had been wounded in General Sherman's March to the Sea a half-century earlier.

This 1909 view shows the wrought-iron fence with stone posts that surrounded the Burton F. Hales mansion, 509 North Oak Park Avenue. The Tudor Revival mansion contained 21 rooms—including 13 bedrooms and 5 fireplaces.

Irving R. Hall drives past the post office at Lake Street and Oak Park Avenue in Oak Park's first motorized mail truck in 1915.

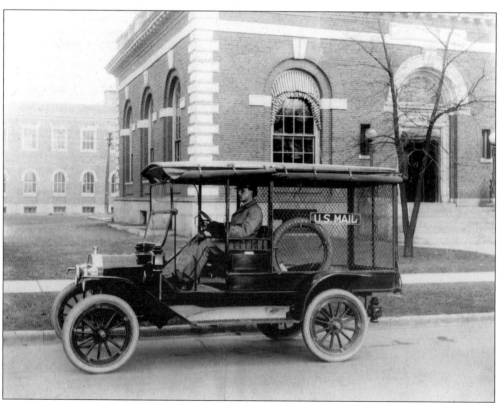

Two

SUBURBIA

In 1871, before the ashes of the Great Chicago Fire had cooled, Oak Park experienced its first huge population boom.

Located on the west edge of the city limits just nine miles from the Loop, Oak Park's proximity to Chicago made the village a highly desirable place to live. The convenient, frequent trains downtown were an especially huge draw.

Since most of the early homes were built within walking distance to the centrally located railroad, Oak Park grew from its middle outward. Shops, banks, and other businesses clustered around the rail stops.

The north and south sections of the community were vast prairies when Oak Park finally managed to sever its ties with Cicero Township to become a self-governing municipality in 1902. Each year there were increasing numbers of newcomers purchasing homes. Soon the electric streetcar and El (elevated) lines enabled even more Loop workers to move out to Oak Park. Schools were constantly being built and expanded.

Oak Parkers a century ago were upright and church-going, prosperous and staunchly Republican. Then as now, the village enjoyed a high degree of citizen involvement.

Settled by temperance advocate pioneers, Oak Park's anti-saloon forces remained strong well into the mid-20th century. No taverns are permitted even now. The community is still pretty "dry," although village statues allow restaurants to serve alcoholic beverages.

As the home of Frank Lloyd Wright for two decades, Oak Park became the nucleus of the Prairie School of architecture in the early 1900s, a rejection of the excess of Victorian style. A virtual revolution in American residential design took place on the elm-lined streets of the village. Oak Park's population continued to boom for decades. The population had been 4,500 in 1890 but quadrupled during the next 20 years. There were 20,000 people living in the village by 1910.

Though it was never a tourist attraction as was Niagara Falls or one of the World's Fairs, there were literally hundreds of different images of Oak Park in circulation during the heyday of the picture postcard. People loved to share their favorite views whenever they'd "drop a few lines" to one another.

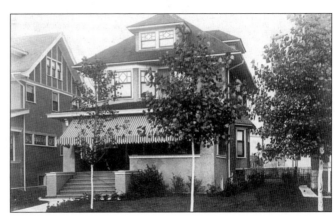

Many new villagers in the early 1900s were attracted to Oak Park by the solid stucco four-square-style homes with wide porches shaded by awnings.

The home on the right with the broad porch, 215 North Euclid Avenue, seen in this 1909 view, is a typical Victorian frame house of the 19th century. It's still standing.

Much of Oak Park was still quite open when this postcard was mailed in 1908. Note the large vacant lots, often called "prairies," on Clinton Avenue at Washington Boulevard.

The Romanesque-style Scoville Institute, a gift of James Scoville in 1888, contained a lending library, a community center, and a gymnasium. This postcard was mailed in 1911. There were dozens of views of this beloved building produced over the years.

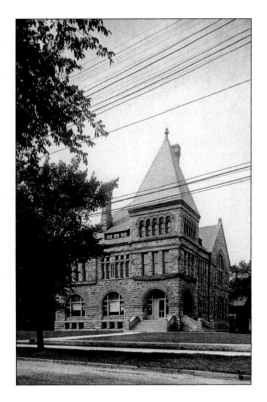

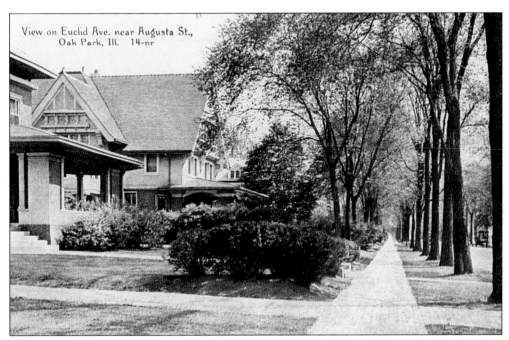

View on Euclid Ave. near Augusta St., Oak Park, Ill. 14-nr

Though only a portion of the veranda (left) can be seen in this view, the home designed by Thomas Tallmadge and Vernon Watson for banker Ashley C. Smith in 1908 at 630 North Euclid Avenue is a classic Prairie-style home.

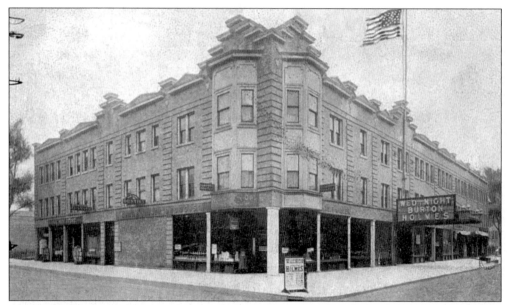

The Warrington Opera House, 104 South Marion Street, was designed by E.E. Roberts in 1902. With a seating capacity of 1,500, the theater featured live performances of stage plays and vaudeville shows. When this 1907 postcard photo was taken, a Burton Holmes travel lecture was playing. For the last 40 years of the 20th century, the building functioned as a banquet facility. A mid-rise condo building was proposed for this site in 2003.

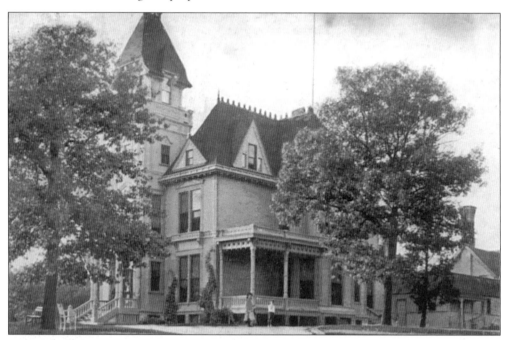

James Scoville's imposing 1880 Victorian mansion was used as a finishing school for girls at the time this postcard was mailed in 1908. Free patriotic and ragtime band concerts were popular here on Sundays. In 1912, after the house was razed, the hilly grounds became Scoville Park, Oak Park's first public park. In 1925, the World War I Memorial monument was dedicated on this site.

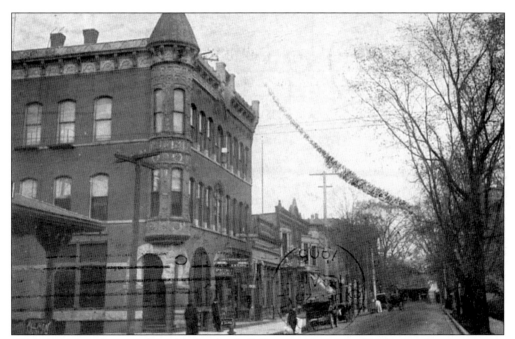

This 1906 view shows Oak Park's first bank (left), opened in 1887 by the Dunlop Brothers. It was located on the north edge of the street-level railroad tracks at Marion Street and North Boulevard. The turret and Victorian detail were removed to modernize the structure in the 1960s. Recently the building has contained a bakery and florist.

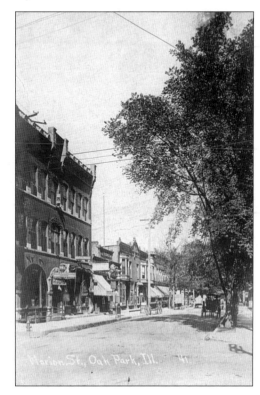

This is the same view, looking north on Marion Street from the North Western tracks at the business hub of the village. The block-long commercial strip offered everything from Bromo Seltzer to bicycles. This postcard was mailed by local photographer Philander Barclay in 1907.

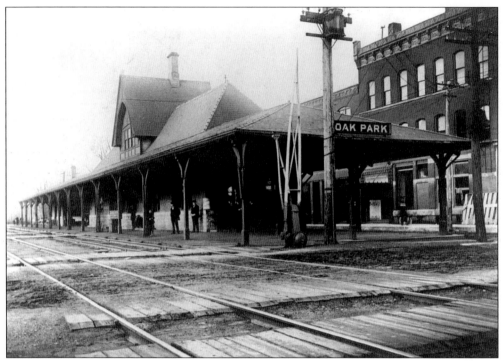

The street-level North Western tracks and depot are seen here well before the hectic rush hour. Most of the homes of the era were within walking distance of one of the stations.

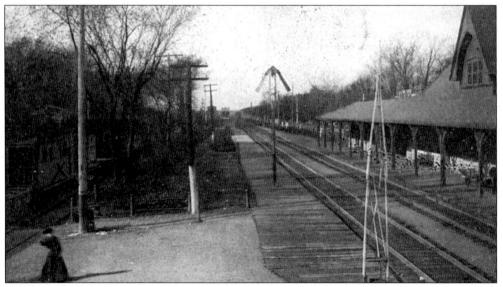

The Marion Street depot was at the business center of the village. Two crossing gates were the only protection for pedestrians at the street-level tracks. Every year there were many fatalities until the trains became elevated in 1915. The CTA tracks remained at ground level until the early 1960s.

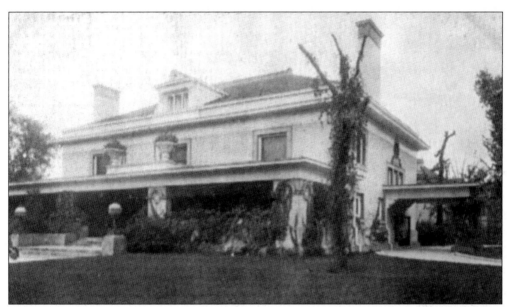

Pleasant Home, 217 Home Avenue, was designed by Prairie School architect George W. Maher in 1897 for millionaire banker John Farson (1855-1910). Known for his generosity, Farson welcomed his fellow Oak Parkers to enjoy his seven acres of landscaped grounds and gardens.

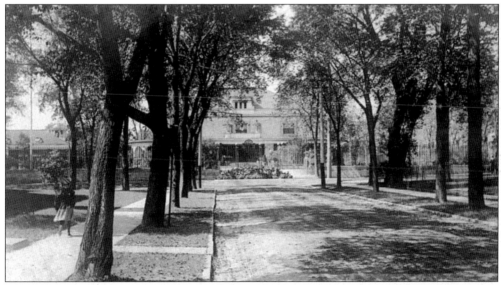

When roller-skating became a fad, Farson not only added smooth cement walks to his grounds, but also routinely left the front gates wide open. He encouraged neighbor children to skate on his broad front porch, and even took up the sport himself. Pleasant Home is now owned by the Park District of Oak Park and for decades has housed the local historical society.

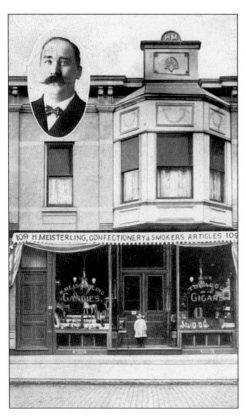

Main streets in Oak Park were newly paved with bricks in 1908. Typical of many merchants of the era, the family of H. Meisterling lived upstairs above their candy and tobacco shop, 1144 Lake Street.

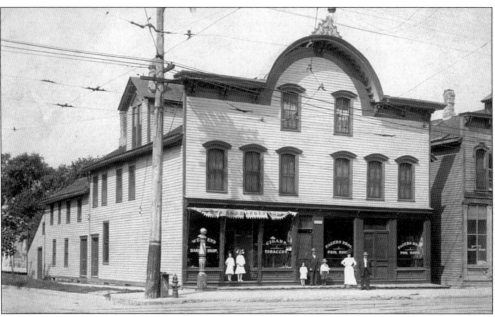

The frame storefront building on the northeast corner of Lake Street and Harlem Avenue in 1910 contained a pool hall, tobacconist, and barbershop. In 1929, Marshall Field's was erected on this corner.

The Park Hotel, 110 North Marion Street, was located a half block north of the street-level railroad depot. Visitors to the village—especially traveling salesmen and theatrical performers from the nearby Warrington Opera House—raved about the 35¢ "table d'hote" dinners. Today a men's clothing store occupies this building, which has been drastically altered.

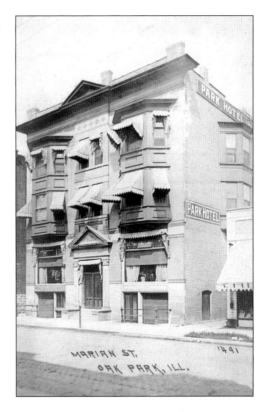

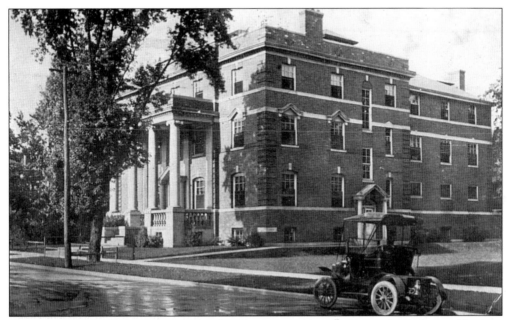

This postcard, postmarked 1911, shows the YMCA gymnasium addition (rear) designed by E.E. Roberts. Charles B. Scoville donated the lot at 156 North Oak Park Avenue and launched the building fund for the Y. The 1904 building is now an upscale condominium development.

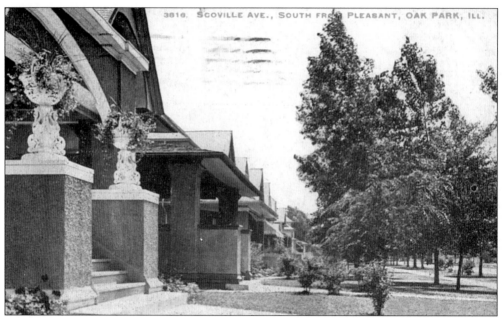

People have long taken umbrage with a remark attributed to native son Ernest Hemingway that Oak Park was a town of "broad lawns and narrow minds," but no one has ever been able to locate the source of this supposed quote. Here we see some typical broad lawns at Scoville and Pleasant in a view postmarked 1914.

The corner house (left), 200 South Elmwood Avenue, was altered considerably since this postcard was mailed in 1912. When the entrance was relocated to the south side of the home, the broad front porch was enclosed and included as part of the living area. The small sapling elms, full-grown by the 1950s, became casualties of the epidemic of Dutch Elm Disease that struck the village in mid-century.

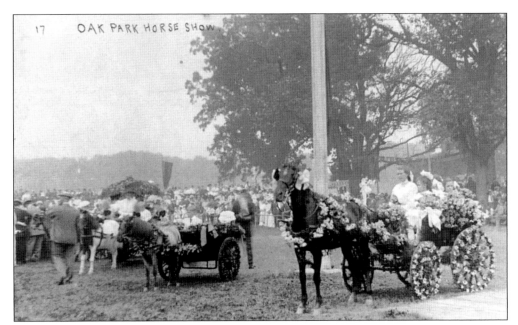

The Oak Park Horse Show, the highlight of the social season in the early 1900s, featured judged events in a variety of categories. Here we see the pony cart competition. When local equestrienne Helen Hayden refused to ride her horse, "Fair Oaks Gloria," side-saddle, she became the first woman in the village to wear a divided riding skirt.

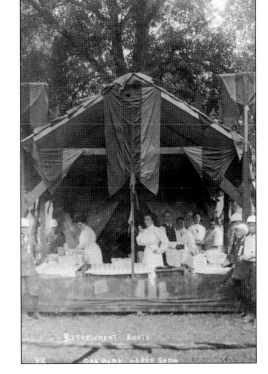

The ladies in the Horse Show refreshment stand sold home-made box lunches, frankfurters, and Coca-Cola. All profits from the Horse Show went to the Hephzibah Orphanage and other local charities. This annual event took place on the grounds of what is now Cummings Park, northwest corner of Harlem Avenue and Lake Street.

35

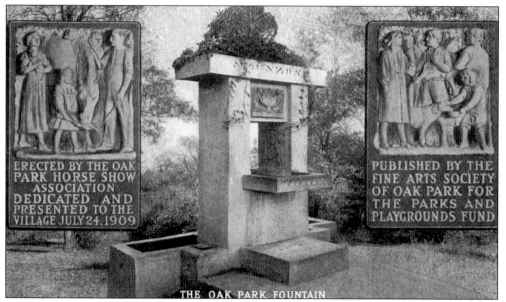

THE OAK PARK FOUNTAIN

ERECTED BY THE OAK PARK HORSE SHOW ASSOCIATION DEDICATED AND PRESENTED TO THE VILLAGE JULY 24, 1909

PUBLISHED BY THE FINE ARTS SOCIETY OF OAK PARK FOR THE PARKS AND PLAYGROUNDS FUND

The Horse Show Fountain, commissioned by the local Horse Show Association in 1909, was designed by Frank Lloyd Wright, with sculpture by his frequent collaborator, Richard Bock. When the architect fled to Europe with his lover, Mrs. Mamah Cheney, the wife of a client, his actions aroused so much hostility that Wright was rarely given credit for the fountain's design.

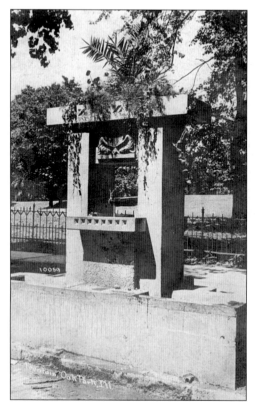

Originally, the Horse Show Fountain stood mid-block on Lake Street—close enough to the curb so horses could drink from its lower level. In 1969, the concrete fountain was reconstructed and relocated near the corner of Oak Park Avenue and Lake Street.

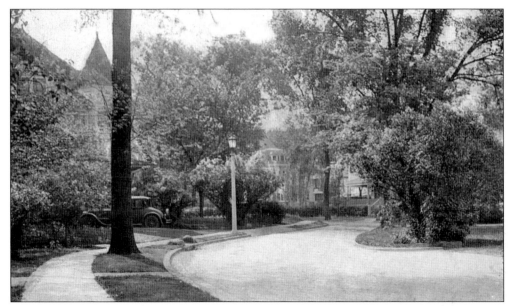

Named after Elizabeth Humphrey, wife of a prominent Oak Park minister, Elizabeth Court is the only curved street in the village. In the 1870s, its residents so vigorously protested plans to straighten the thoroughfare that Cicero Township officials passed an ordinance protecting its design.

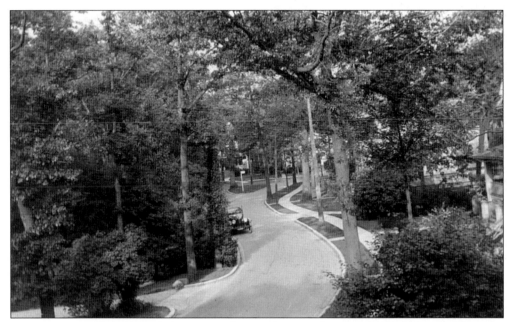

Picturesque, curving Elizabeth Court, seen here on a postcard postmarked 1922, today still retains the original 19th-century numbering system, going from west to east.

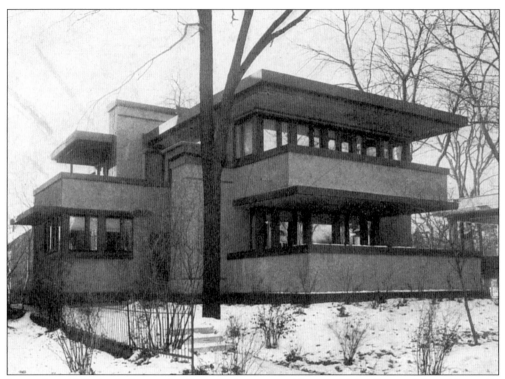

Located at 6 Elizabeth Court, the frame and stucco residence of Mrs. Laura Gale, widow of a realtor, was designed by Frank Lloyd Wright in 1909. The flat roof, stucco walls trimmed in wood, and cantilevered balconies make the home seem like the prototype for Wright's best-known work, "Fallingwater" (1936) in Pennsylvania.

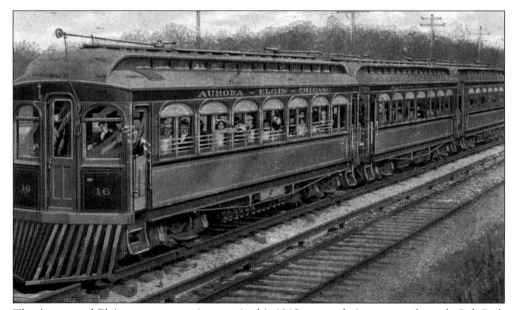

The Aurora and Elgin commuter train, seen in this 1912 postcard view, came through Oak Park on street-level tracks where the Eisenhower Expressway is now located.

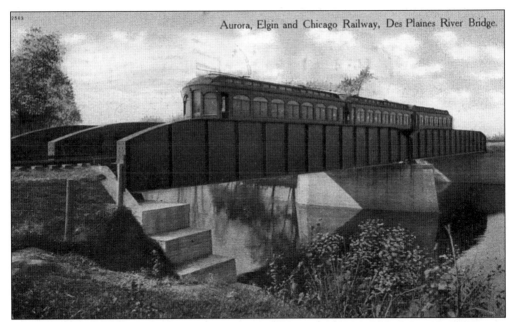

In 1924, the name of the train was reversed to Chicago, Aurora and Elgin Railroad.

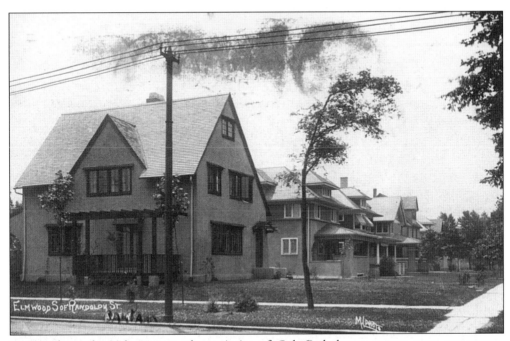

During the early 20th century, the majority of Oak Park home-owners were prosperous, Protestant, and Republican. This postcard, mailed in 1912, shows the corner of Elmwood Avenue and Randolph Street.

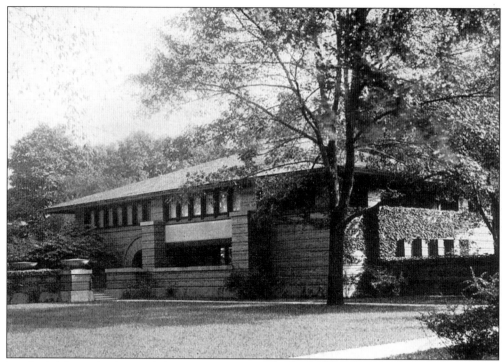

Frank Lloyd Wright designed the home of banker Arthur Heurtley, 318 Forest Avenue, in 1902. The house is classic Prairie School style, with its broad, low chimney, sheltering hip roof, and bands of windows and protruding rows of bricks emphasizing the horizontal.

A buggy passes the Arthur Heurtley home, 318 Forest Avenue. Located a half block south of Wright's own residence, it is one of the grandest of the architect's residential designs.

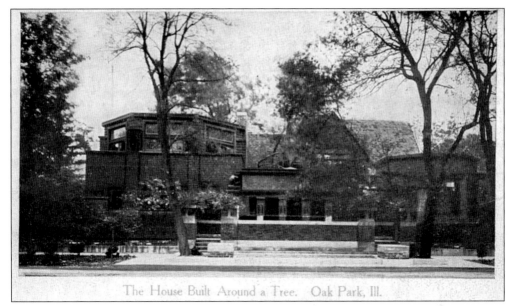

The House Built Around a Tree. Oak Park, Ill.

Frank Lloyd Wright (1867-1959) had angered many of his fellow Oak Parkers when this view of 951 Chicago Avenue was printed in 1909. The architect is not even identified on the postcard. Actually this is not his home, as indicated by the caption, but his architectural office, which was attached to Wright's house by a covered passageway.

Postmarked 1908, this view was mailed by one of Mrs. Catherine Tobin Wright's cousins. In 1911, the architect left Oak Park, closed his office, split up his home into rental units, and moved his family into his former studio (right).

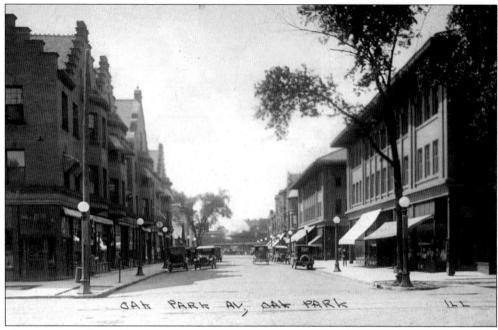

The 1908 Scoville Building (right), sometimes called the Masonic Block, at Lake Street and Oak Park Avenue contrasts sharply with the European-style commercial complex across the street. Architect E.E. Roberts' Prairie style emphasizes the horizontal, such as its ribbons of windows and its wide, over-hanging eaves.

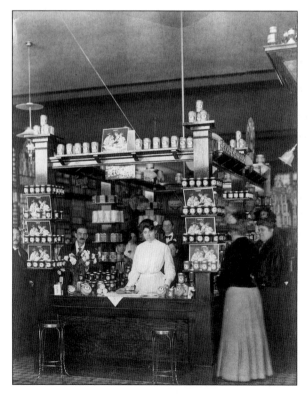

Many of the shops in the Scoville Building, such as the Nissen-Puchner Grocery, 121 North Oak Park Avenue, showed interior Prairie-style detailing and decoration (1908).

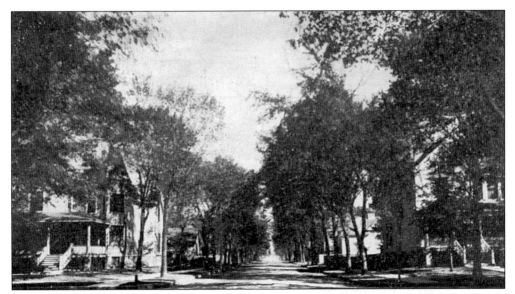

Scores of 19th-century Oak Park homes, such as these seen at Washington Boulevard at Maple Avenue in this 1908 postcard view, were razed during the 1920s to clear the way for large courtyard apartment complexes.

The home on the left at 139 South Grove Street, with its broad front porch and prominent gables, was designed by H.G. Fiddelke in 1894. The total cost was $17,000—an astronomical price for a house at that time. This postcard was mailed in 1907.

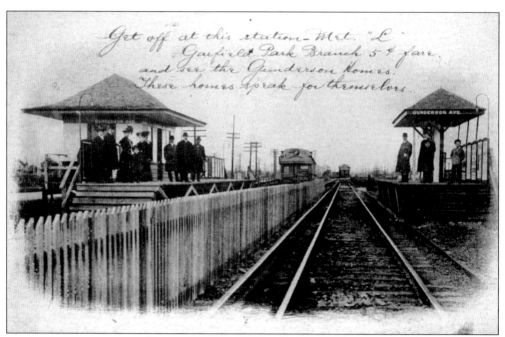

Get off at this station—Met. "L" Garfield Park Branch 5¢ fare, and see the Gunderson Homes. These homes speak for themselves.

Much of south Oak Park was a vast, undeveloped prairie when Seward Gunderson subdivided large tracts of land and began building hundreds of comfortable, affordable homes. Gunderson even persuaded the Garfield Park Elevated authorities to build a "Gunderson Avenue Station" at the ground-level El tracks to provide commuter access to his new subdivision.

Beginning in 1906, Seward Gunderson built over 600 homes in Oak Park for prices ranging from $4,000 to $10,000. He offered 42 different models. Gunderson lived in one of his own homes, seen here at 701 South Elmwood Avenue.

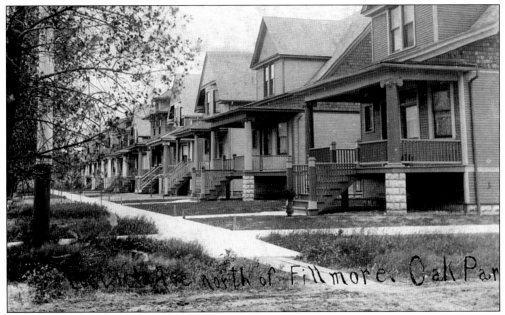

In the first two decades of the 20th century, south Oak Park filled up with homes built by S.T. Gunderson and Sons, Thomas Hulbert, and others. The home on the right, 1146 South Euclid Avenue, seen in this 1910 view, no longer has the Ironic porch columns.

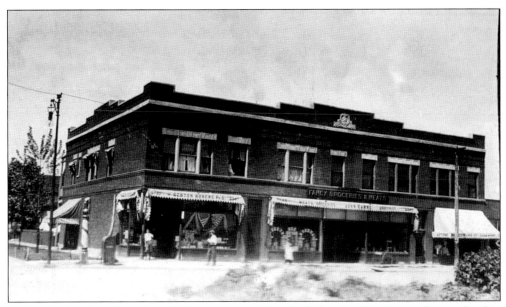

As hundreds of south Oak Park homes were being built by the Gunderson firm and other developers after 1906, an adjacent business district grew up, too. This commercial strip is still situated at Harrison Street and Ridgeland Avenue.

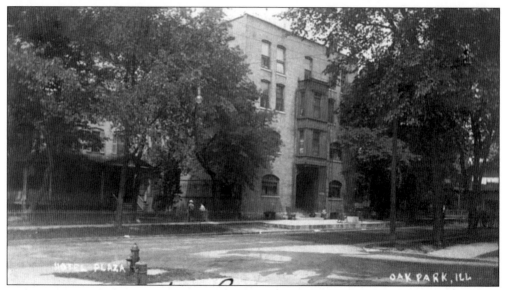

The Hotel Plaza, 123 South Marion Street, was built to accommodate the swell of visitors to the World's Columbian Exposition of 1893 who preferred staying "out in the country" and taking the train to the fairgrounds each morning. Following a fire in the early 1990s, the Oak Park landmark stood vacant for nearly a decade until it was renovated and expanded as part of the adjacent Carleton Hotel.

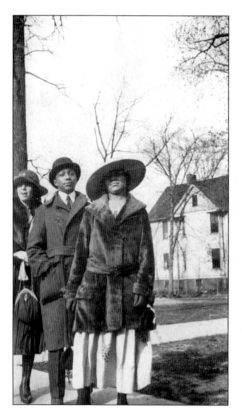

Many people enjoyed sending "snapshot postals" of their family and friends. Such postcards were printed at the drugstore from one's Kodak film negatives. This informal grouping dates from the early 1920s.

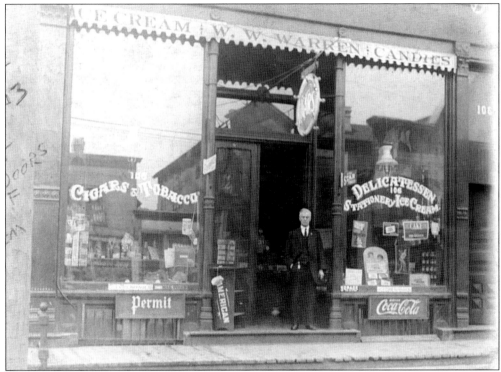

The W. Warren Cigar Store, 1143 Lake Street, *c.* 1912-1913, was actually a convenience store that sold everything from Coca-Cola and school supplies to ice cream and newspapers. Note the wooden sidewalk and the revolving racks of postcards.

Dirt streets in south Oak Park often became treacherous after heavy rains. The person who mailed this postcard in 1910 wrote, "Olive and I are enjoying a Coca-Cola in this drugstore," at Harrison Street and Lombard Avenue. The 200 block of Harrison Street now sports a strip of art galleries.

In 1895, prominent attorney Nathan Moore, a neighbor of Frank Lloyd Wright's, commissioned the architect to design his home at 333 North Forest Avenue in the Tudor Revival style. Moore insisted on this historic English motif, not wanting to "shock the neighbors" with one of Wright's free-flowing buildings.

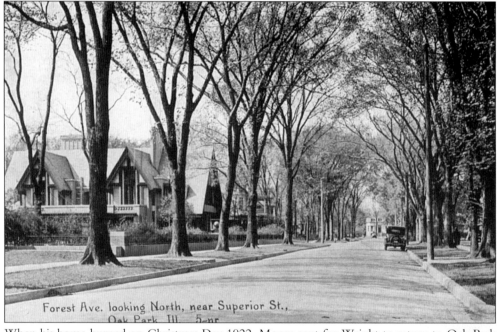

Forest Ave. looking North, near Superior St., Oak Park Ill. 5-nr

When his home burned on Christmas Day 1922, Moore sent for Wright to return to Oak Park to redesign and rebuild it on the original foundation. The details in the resulting reconstruction (left) reflect the Japanese influence of Wright's recently completed Imperial Hotel in Tokyo. Wright also reduced the home from three to two stories.

The arrival of moving pictures altered the way Oak Parkers spent their leisure hours during the 1910s. Free movie star postcards plugged upcoming features at the four silent movie theaters: The Oak Park, 120 South Marion Street; The Playhouse, 1111 South Boulevard; The Elmwood, 631 Harrison Street; and the Southern, 828 South Oak Park Avenue.

These two souvenir postcards, handed out at the Elmwood Theater, feature Mary Pickford ("America's Sweetheart") and Marguerite Clark, silent movie rivals for innocent, waif-like roles, c. 1916. The Elmwood was razed in the 1950s during the construction of the Eisenhower Expressway.

Oak Park neighborhoods contain a diverse array of architectural styles. The house on the left, 300 South Scoville Avenue, is clearly Prairie School, with its strong horizontal emphasis. Further down the block are the turrets and towers of Victorian-era Queen Anne homes.

Bungalows were popular and affordable during the 1910s and 1920s. Many models were priced around $2,000. This postcard shows the bungalow belonging to Herman and Anna Strubing, 820 Wenonah.

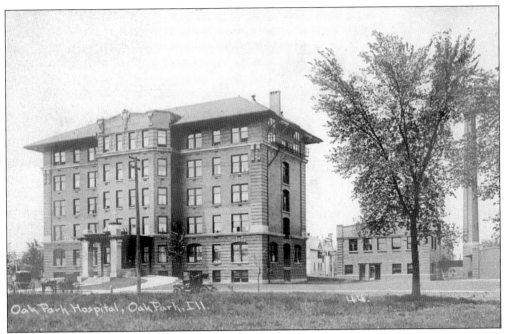

Until Oak Park Hospital, 525 Wisconsin, was erected in 1907, patients had to be transported five or six miles to Chicago hospitals. The new hospital attended the momentous events in the life cycle (birth and death) that previously took place at home.

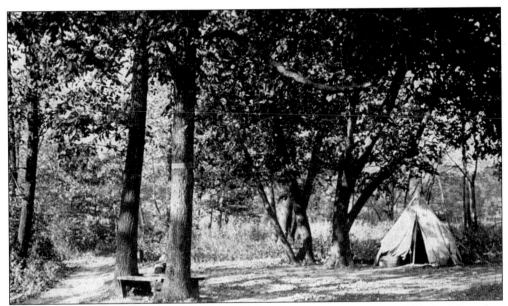

During his high school years (1913-1917), teenager Ernest Hemingway and his buddies often camped in the thick woods along the Des Plaines River. Before the European settlers arrived in the 1830s, the river had been a main canoe thoroughfare for the Potowatomi tribe.

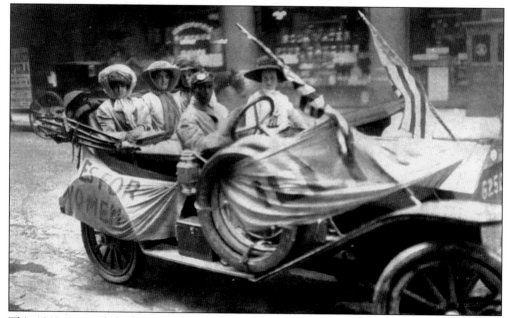

This 1910 postcard shows Oak Park's leading suffragette, Grace Wilbur Trout, a tireless leader and gifted speaker (backseat, left). Trout organized "Automobile Caravans" through the Midwest to generate support and raise funds for the women's suffrage cause.

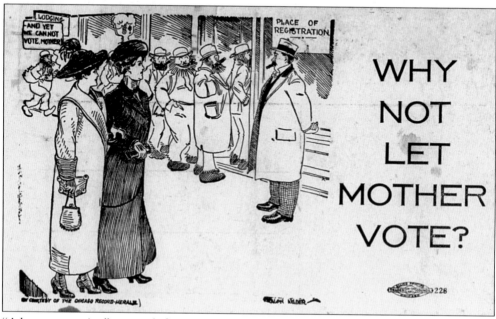

"Advance campaign" postcards featuring suffragist cartoons were mailed from Mrs. Trout's Oak Park home to stops along the route of her speaking tours. This one is postmarked 1912.

The women's suffrage movement was not without its backlash. This cartoon postcard, part of a 1910 series, poked fun at liberated suffragettes who forced their husbands to assume their domestic duties.

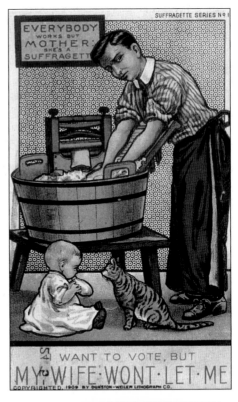

From the beginning, Oak Park was known for its picturesque tree-lined streets. This 1906 view shows the large European-style, three-story complex of stores and "flats" called the Scoville Block, located at Lake Street and Oak Park Avenue, which was erected in 1899.

This view of Oak Park Avenue from Ontario Street shows there was an increasing amount of auto traffic by the early 1920s. When it was dedicated in 1904, the YMCA had the second largest indoor swimming pool in the country. Today, the building is a condominium complex.

Oak Park's 1905 post office, just south of the Y on the northeast corner of Lake Street and Oak Park Avenue, was auctioned off, then demolished, in the mid-1930s to make way for a commercial strip.

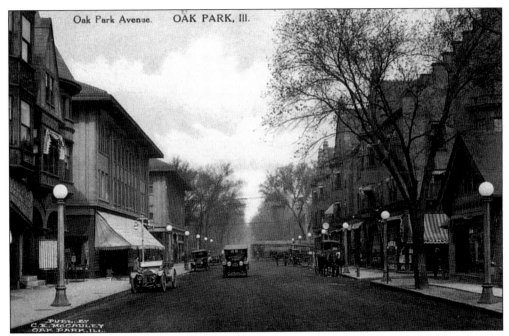

Looking north to the intersection of Oak Park Avenue and Lake Street, we see both autos and horse-drawn traffic in 1911. Note the Lake Street streetcar in the distance. Trees were still plentiful in the business district, too.

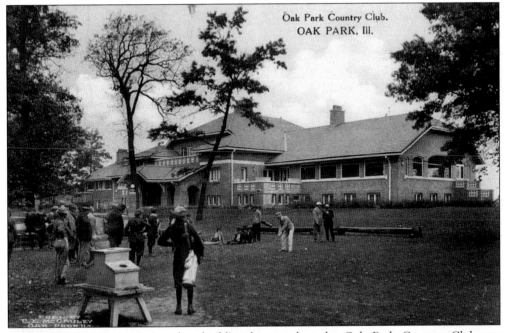

Oak Park was experiencing such a building boom when the Oak Park Country Club was founded in 1914 it was necessary to build outside the village in order to afford enough land for golf. This view shows the Thatcher Road and Armitage Avenue location, just north of River Forest. Membership was initially limited to 300.

This group of new recruits at Camp Grant posed for a postcard they could mail home to friends and family in Oak Park before being shipped overseas to fight in World War I in 1917.

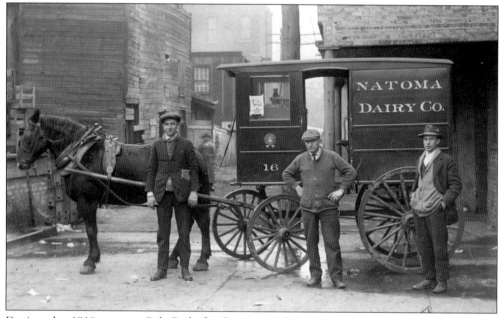

During the 1910s, many Oak Park families invested in automobiles, yet most commercial vehicles continued to be horse-drawn for a few more years. The Natoma Dairy Co., 1124 William Street (now Westgate), boasted about its delivery of "perfect milk, cream & eggs". Ben Schaffer is the man on the left.

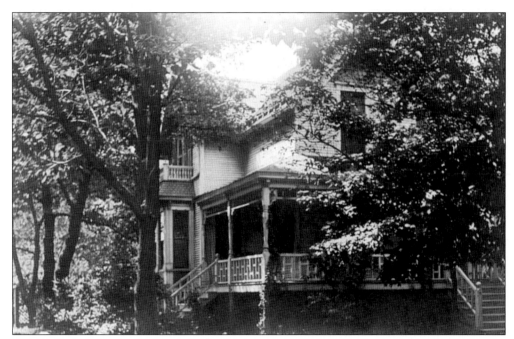

Ben Schaffer, pictured on the previous page working for the Natoma Dairy, lived here at 739 North Marion Street. The house still looks much as it does in this 1908 postcard.

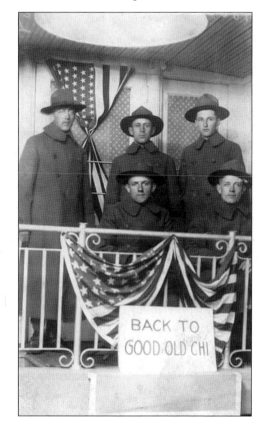

There were 1,950 enlisted men from Oak Park in service during World War I. Ben Schaffer (standing, right) was one of them. Ben mailed this studio-made postcard home to family and friends before returning in early 1919. Fifty-six Oak Park men were killed in the First World War.

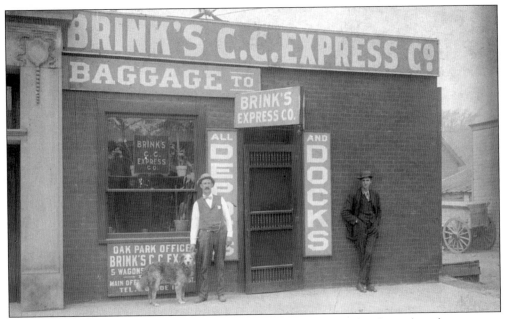

Travel was rigorous and challenging in the early 20th century. In the days when there was no such thing as a quick trip, Brink's Express, 205 Marion Street, was in the business of delivering people's bulky trunks to trains and ships in downtown Chicago.

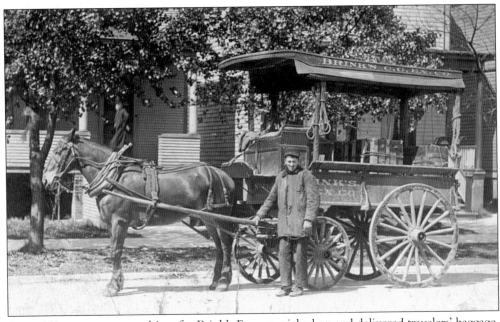

George Simmons, a young driver for Brink's Express, picked up and delivered travelers' baggage.

Three
E.E. ROBERTS

Though he worked in the same village at the same time as internationally acclaimed Frank Lloyd Wright, the name E.E. Roberts is hardly a household word today. Yet Eben Ezra Roberts (1866–1943) was Oak Park's most popular architect in the early 20th century.

Born in Boston, Roberts settled in Oak Park in his 20s. Between 1893 and the 1930s, he designed over 250 buildings, from schools and churches to stores and theaters. His specialty, however, was residential work. He catered to the popular taste, advertising himself simply as an architect of "homey buildings."

Roberts designed many Prairie School buildings but worked widely in all architectural styles. Although they were neighbors whose children were frequent playmates, Wright and Roberts remained competitors, not friends. They had little in common. Roberts, for instance, was happily married for over 50 years.

Wright loathed Roberts' conventional designs, many of which included classical details, such as Greek columns. He often mockingly referred to Roberts' square, symmetrical stucco homes as "soap boxes."

Though many of his buildings are now part of "lost Oak Park," numerous other structures designed by E.E. Roberts, from the First Baptist Church to the Adele Maze Branch Library, are still much a part of life in the village.

During a long, productive career, Roberts' work was documented with scores of stunning postcard images that continue to celebrate his architecturally diverse contribution to Oak Park.

E.E. Roberts' office was in the Dunlop Bros. Bank building, later bought out by Oak Park State Bank. He advertised weekly in the local press.

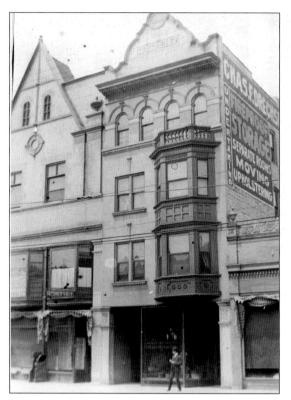

The four-story brick Drechsler Building, 1116 Lake, was designed by E.E. Roberts for Charles Drechsler, Oak Park's first mortician in 1898. It was the only steel reinforced building west of the Loop. A growing number of families began to prefer services in a funeral parlor rather than in their own front parlors. Early undertakers often took on the work as a sideline of their furniture business, since they were usually called upon to build wooden coffins.

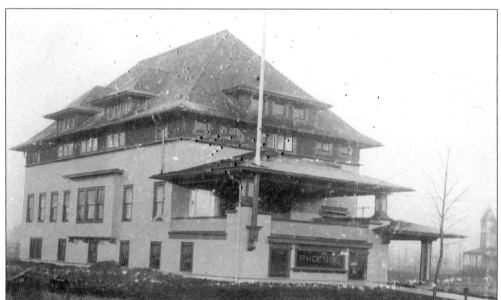

The Phoenix Club, 641 South Scoville Avenue, one of many social clubs in Oak Park, was located on the vast undeveloped "south prairie" of the village. Designed by Roberts in 1902, the building had a wide porte cochre for arriving carriages. Inside were bowling alleys, a billiard room, smoking parlors, a library, a banquet hall, a ballroom, and stage. A building designed in the Prairie style is now on this site.

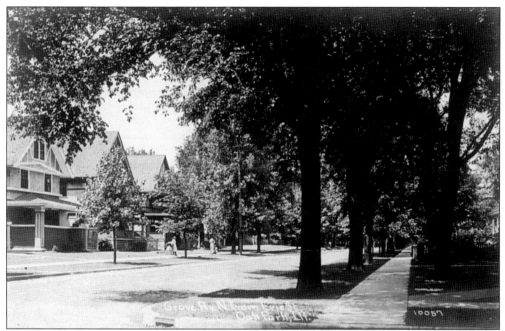

E.E. Roberts designed the "speculation homes" at 303–319 North Grove Avenue in 1896. The six houses have similar floor plans but exhibit different detailing and ornamentation. The house on the left, 309 North Grove, is typical of the type of spacious residence sought by the increasing numbers of prosperous families moving into Oak Park at the turn of the last century.

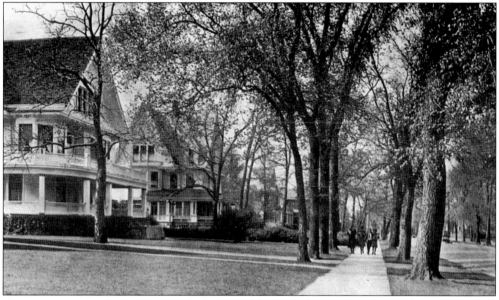

These two stately Queen Anne-style homes with classical ornamentation and steeply pitched roofs were designed by E.E. Roberts for the banker Dunlop brothers. Simpson Dunlop's house (417 North Kenilworth Avenue), left, was erected in 1896. Joseph's home (407 North Kenilworth) next door was completed in 1897.

Roberts' 1900 home for Andrew Jackson Redmond, 422 North Forest Avenue, is located directly behind the Dunlop brothers' homes and two doors south of Frank Lloyd Wright's residence. The symmetrical residence features a broad porch, wide eaves, a tile roof, and huge planters.

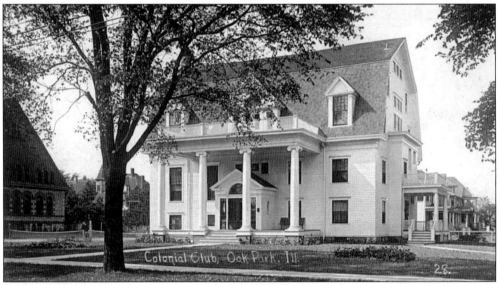

The Colonial Club, 450 Lake Street, was situated on what is now known as the Farmer's Market parking lot adjacent to Pilgrim Church. This three-story clubhouse, designed by Roberts in the 18th-century Colonial style, was dedicated in 1904. Note the barn-like gambrel roof and classical porch. The family-oriented social club contained a billiard room, bowling alleys, parlors, clubrooms, and a third floor ballroom. The building was razed in 1972.

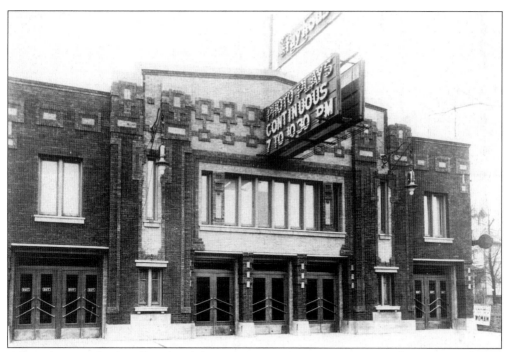

Oak Park was said to be afflicted with "movie madness" in 1913: there were five new silent move theaters built in the village that year. The Playhouse, 1111 South Boulevard, contained 600 seats on the main floor and 100 in the balcony. Roberts' design was known for its motorized "glass ceiling," a retractable series of skylights which could slide open to allow the audience to cool naturally on summer nights. The structure now functions as an office building.

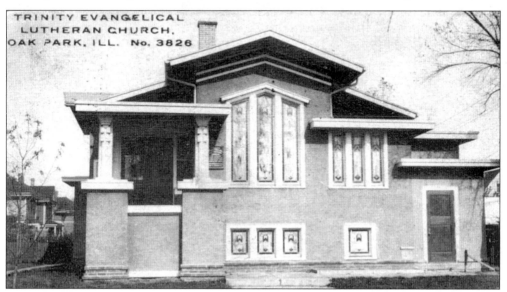

In 1909, Roberts designed Trinity Lutheran Church, 300 North Ridgeland Avenue, in a decidedly Prairie School idiom, with a horizontal emphasis and windows grouped in threes. Seven years later, the Prairie style was defaced when the building was expanded along Ridgeland Avenue with a more medieval, historic look.

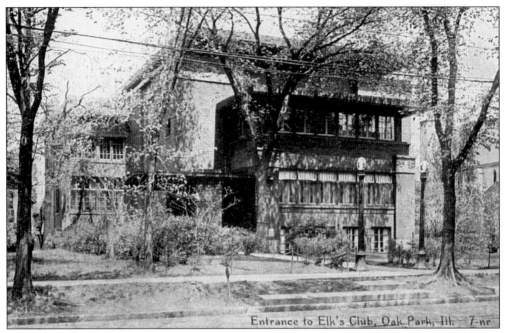

The three-story Elks Club, 938 Lake Street, was designed for the Benevolent Order of Elks in 1915. Note Roberts' Prairie-style horizontal emphasis, despite the height of the structure. Meetings were held on Monday evenings, but the clubhouse was open every day for recreational purposes.

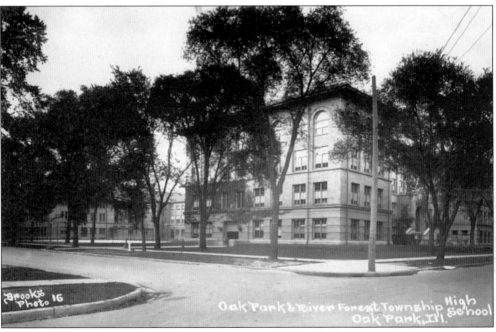

Roberts designed the north section of Oak Park High, which faces Erie Street, in 1912. The school was one of the largest and finest public high schools in the region.

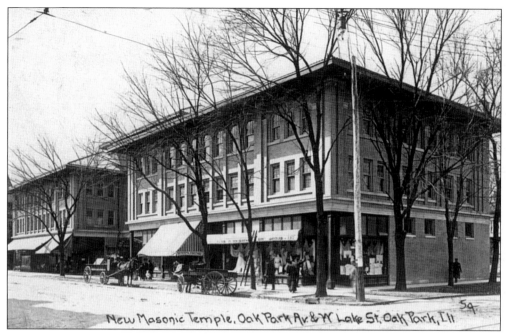

The Scoville (Masonic) Block, erected in 1908, 121-151 North Oak Park Avenue, exhibits a strong Prairie style. Note the broad overhanging eaves, the ribbons of windows, and the recessed main entrance. A popular eatery has been situated in the corner space in recent years.

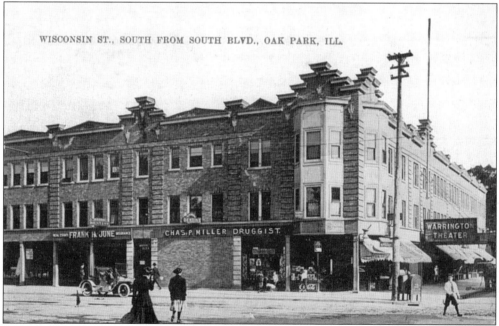

Theatrical stock companies were booked at the Warrington Opera House, 104 South Marion Street. Designed by E.E. Roberts in 1902, this "3-a-day house" featured vaudeville acrobats, comedians, jugglers, and musicians until the advent of "talkies" and the Great Depression.

In 1908, E.E. Roberts designed the prominent entrance façade, band shell, and dancehall of the Forest Park Amusement Park, Harrison Street at Des Plaines Avenue. (Previously, the village of Forest Park had been called Harlem.)

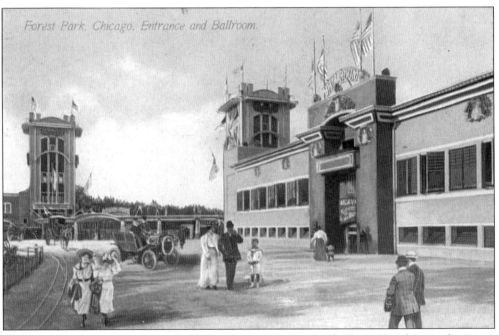

Most of the roller coasters and buildings burned in a spectacular fire in 1923. The popular Forest Park Amusement Park never re-opened.

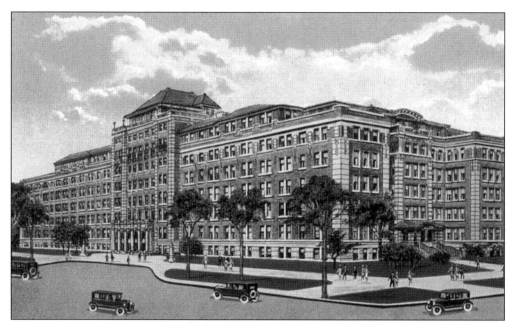

Roberts' 1914 design for West Suburban Hospital, 518 North Austin Boulevard, was designed with an emphasis on symmetry and classical detail.

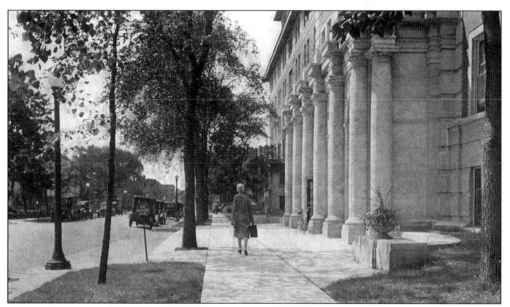

This 1929 postcard shows the prominent Greek columns at the front of West Suburban Hospital. By this time, "West Sub" had 425 beds and 8 operating rooms.

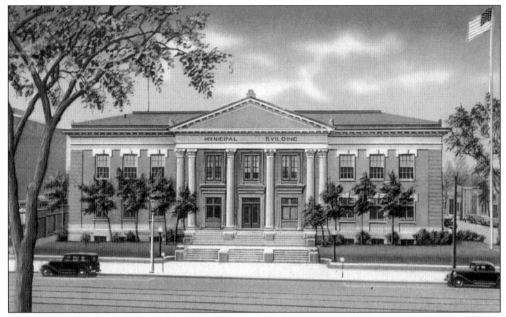

Oak Park's Municipal Hall (1903), one of Roberts' best-known Oak Park structures, was located at Lake Street and Euclid Avenue. It was featured on at least a dozen postcard images. This 1930s view illustrates the building's strong classical symmetry.

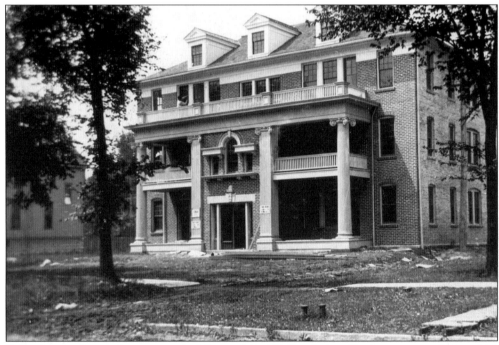

"The Geneva," a small apartment building at 111–113 South Scoville Avenue, was designed by E.E. Roberts in 1902. Today the porches are enclosed, thus adding more living space.

Abraham Lincoln School, 1111 South Grove Street, no longer looks as it did in 1907 when Roberts designed the building on the fast-growing south prairie of Oak Park.

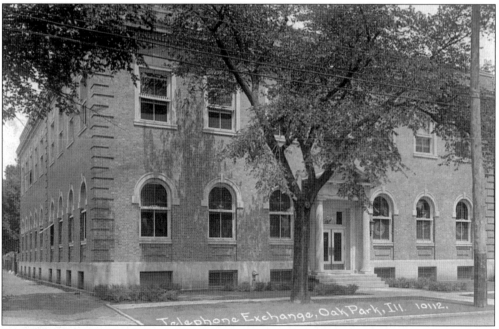

The Telephone Exchange, designed by Roberts in 1914, was located at 714 Lake, just west of Euclid Avenue. The Oak Park telephone office building was the district headquarters for the western suburban area.

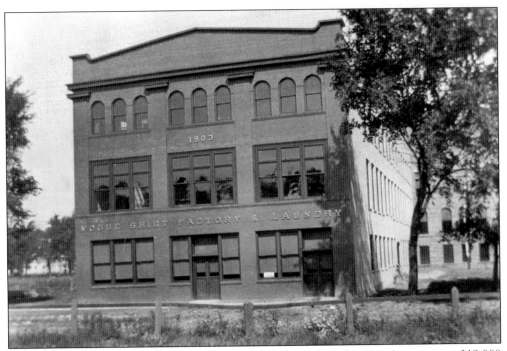

Designed in 1903, the Vogue Shirt Factory, 600 North Boulevard at East Avenue, cost $18,000 to construct and was one of Oak Park's few industrial ventures. Later occupied by Brooks Laundry, the E.E. Roberts building was demolished in the 1950s.

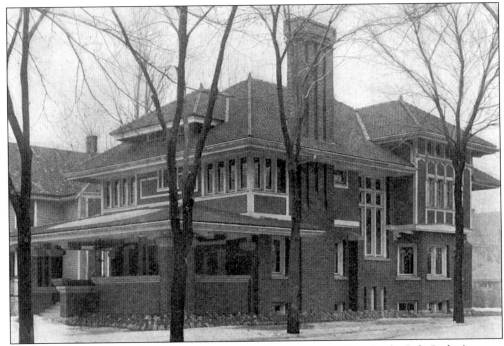

Roberts' Prairie-style 1905 home for Dr. Charles E. Cessna, 524 North Oak Park Avenue, features a wide, low, cavernous porch, and a two-story bay on the south façade.

The home of J.E. Murray, 703 North East Avenue, was designed by Roberts in 1915 toward the twilight of the Prairie period. There was an elevator and two maids' rooms.

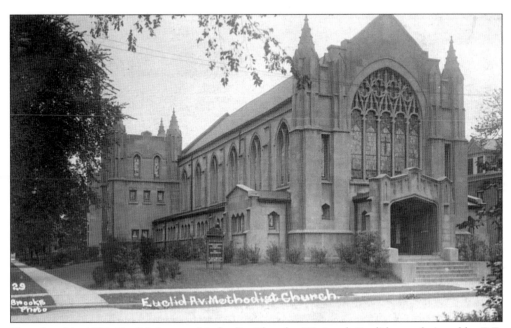

Completed in 1922, Euclid Avenue Methodist Church, 405 South Euclid, was designed by E.E. Roberts in the Norman Gothic style.

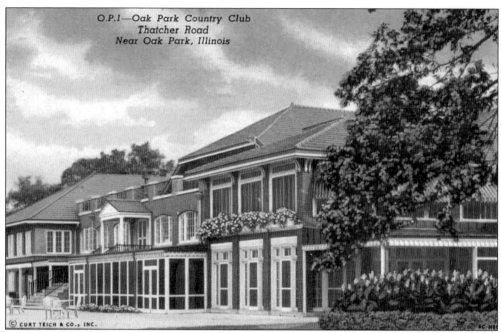

This postcard view of the Oak Park Country Club was mailed in 1952. Roberts had been commissioned to create a clubhouse "in the English country style" in 1914.

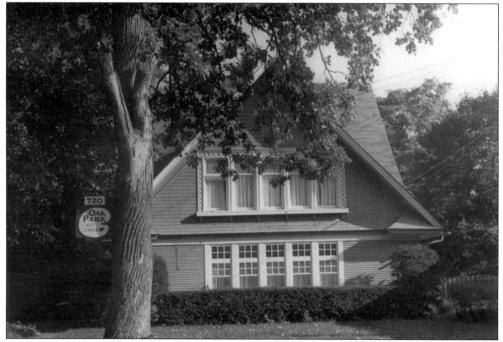

In 1937, E.E. Roberts, a member of the Oak Park Art League, adapted a 1902 carriage house at 720 Chicago Avenue into the permanent headquarters for the organization. He designed classroom and gallery space in what had been a stable.

Four
WORLD'S LARGEST VILLAGE

During the 1920s, like the rest of the nation, Oak Park experienced the most spectacular economic boom the village had ever seen. As chain stores and department stores from F.W. Woolworth's to Marshall Field's opened in Oak Park, the downtown business district acquired regional status as the finest shopping center of the western suburbs. During this period, advertising postcards were increasingly used to promote local products and businesses.

Oak Park's population continued to swell, as the former prairies of north and south Oak Park were filled in and built up. In 1910, there had been 20,000 villagers. By 1920, there were 40,000. But according to the 1930 census, the population had swollen to 64,000. Oak Park had become the world's largest village.

There were 107 miles of paved streets and 50 miles of paved alleys. There were 7 club buildings and 19 school buildings.

Throughout the 1920s, there was virtual non-stop construction going on all across the village. Many scores of 19th-century homes were demolished to make room for large courtyard apartment complexes and commercial developments.

Oak Park was not without its share of growing pains. Many home-owners viewed the influx of "flat" renters as an invasion of a transient, undesirable element that was a menace to the moral stability of the community.

Yet, even during the Great Depression of the 1930s and the upheaval of World War II, Oak Park continued to improve the quality of village life and move forward.

While the construction of the Eisenhower Expressway during the 1950s caused concern, especially since it necessitated the demolition or moving of numerous south Oak Park homes and businesses, the village managed to not only survive but to thrive and redefine itself when the project was finished.

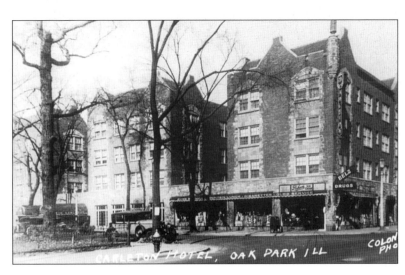

The Carleton Hotel, Marion and Pleasant Streets, opened in 1928. A popular oyster bar with seasonal outdoor seating is now located in the corner drugstore space.

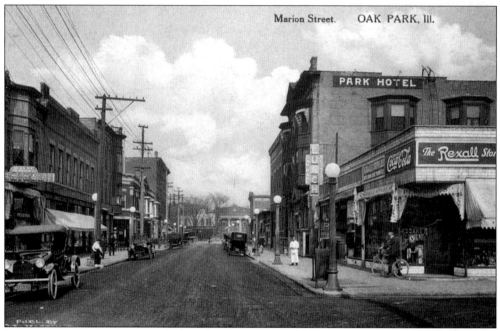

This 1920 view shows the intersection of Marion Street and North Boulevard, then the commercial hub of Oak Park. During the 1970s, a landscaped berm was put in place when this block of Marion Street was blocked off to create a pedestrian mall.

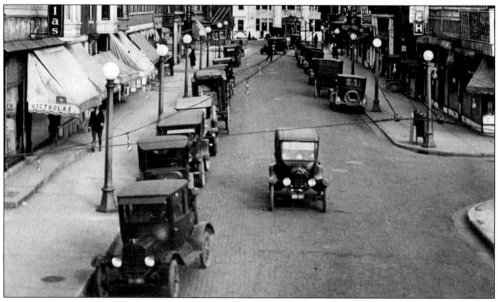

This is the same view in 1924 just after the classical-style Oak Park Savings & Trust had been built on Lake Street. Victrolas (left) were popular hand-cranked phonographs.

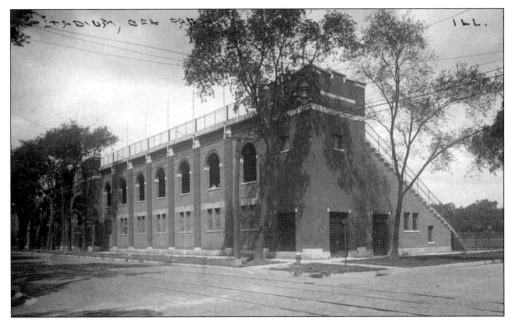

The 6,000-seat High School Stadium at Lake Street and East Avenue was built in 1924 with funding collected by private subscription rather than tax money. Note the Lake Street streetcar tracks.

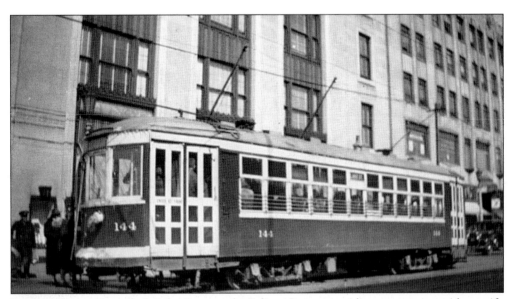

Trolley cars ran along both Lake Street and Madison Street, providing commuters with a swift, cheap means of transportation to the Loop. The Lake streetcar, seen here in front of Marshall Field's, *c.* 1937, was used heavily by both shoppers and students en route to the high school. For decades, the fare was a nickel.

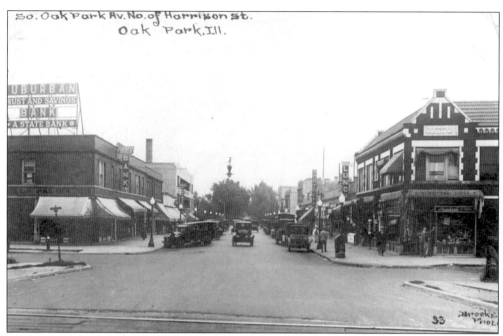

South Oak Park had its own business district by the early 1920s. This view shows the intersection of Oak Park Avenue and Harrison Street looking north from the street-level El tracks. There were lunch counters, a Woolworth's dime store, a Piggly Wiggly, and the Southern Theater—a silent movie house with 550 seats.

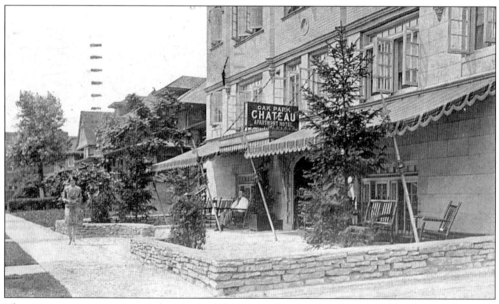

The Terrace, an apartment hotel at 330 North Austin Boulevard, offered "comfort and convenience" to its residents in the 1920s. Yet some Oak Parkers feared such developments might cause an "invasion of a transient, undesirable element."

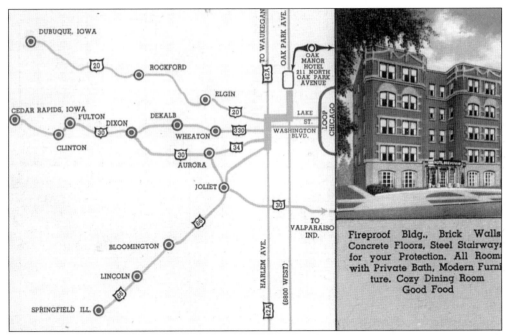

Fireproof Bldg., Brick Walls
Concrete Floors, Steel Stairways
for your Protection. All Rooms
with Private Bath, Modern Furni-
ture. Cozy Dining Room
Good Food

Hotels provided their guests with free postcards, often with easy-to-follow directions. The Oak Manor Hotel, 211 North Oak Park Avenue, offered fine dining and a radio in every room in 1938. But prices were steep for the period—a single room rented for $3 a day; a double cost $4. The building is still a hotel.

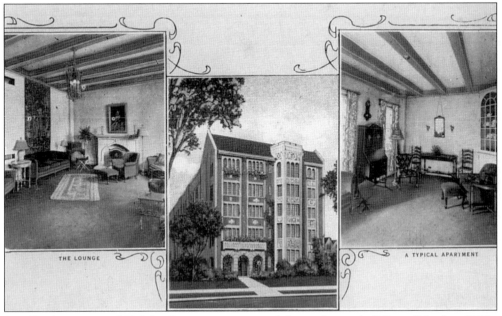

THE LOUNGE

A TYPICAL APARTMENT

Scoville Apartments, 939 Lake Street, was a state-of-the-art luxury building of the late 1920s. Located directly across from the public library, the Scoville featured up-to-date furnishings and full maid service.

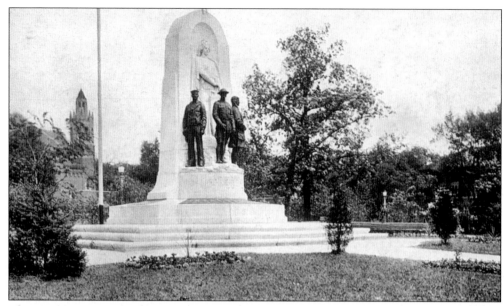

The World War I Memorial on the crest of the hill in Scoville Park cost $55,000. Funds were raised by private subscription. U.S. Vice President Charles Dawes and General John Pershing were present for the dedication of the monument on Armistice Day in 1925.

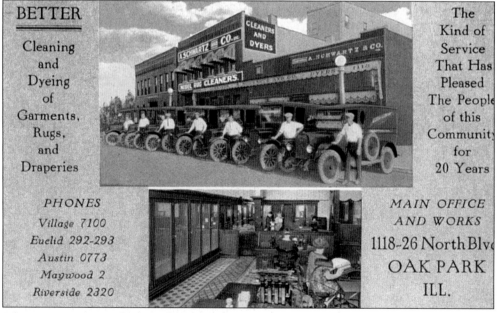

Schwartz & Co. Dry Cleaning Plant was a booming operation with seven delivery trucks by the 1920s when this postcard was mailed out in an advertising campaign. Schwartz & Co. guaranteed one-day service—"spotless, odorless, perfectly pressed."

There were still many homes and trees along Harlem Avenue during the 1920s. This 1927 view shows the intersection of Harlem and Chicago Avenues.

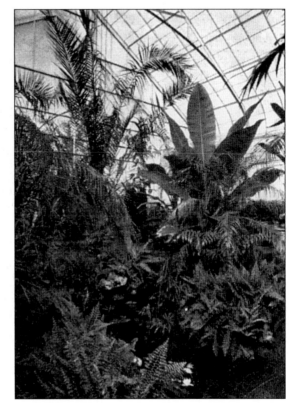

The Oak Park Conservatory, 617 Garfield Street, was completed in 1929. Here, flowers were raised for transplanting to 150 flowerbeds in the various village parks. During the 1930s, the Fall Chrysanthemum Show attracted over 10,000 people annually.

By 1930, Oak Park was known as a chic, fashionable shopping center. Henry C. Lytton & Sons, 1031 Lake Street, the first of the big Loop stores to open an Oak Park branch, sold the best in ladies' cloche hats and men's fedoras.

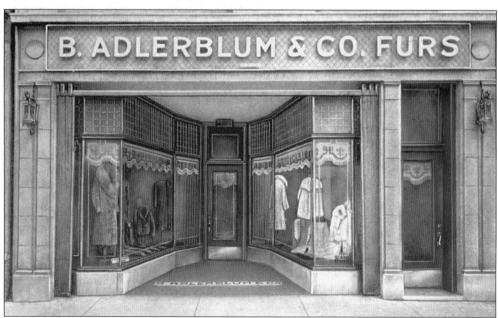

Business was thriving along Lake Street in the late 1920s, just before the stock market crash. Adlerblum Furriers was located in a new store, 1115 Lake Street. The owners, Bernard and Bertha Adlerblum, lived in a flat above their business.

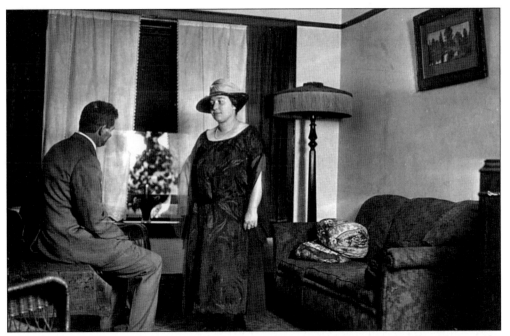

Thousands of new Oak Parkers moved into apartments in the 1920s. This couple resided in a flat at 907 Pleasant Street.

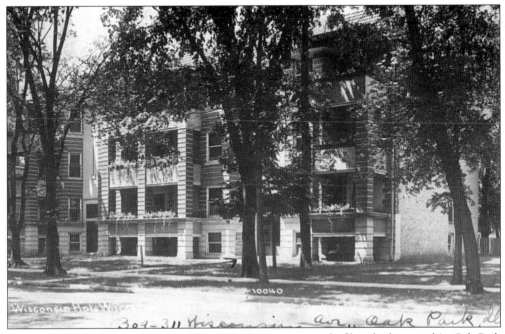

The apartment building at 309-311 Wisconsin Avenue is typical of hundreds erected in Oak Park during the 1920s. Many villagers viewed the boom in the construction of flats with increasing alarm.

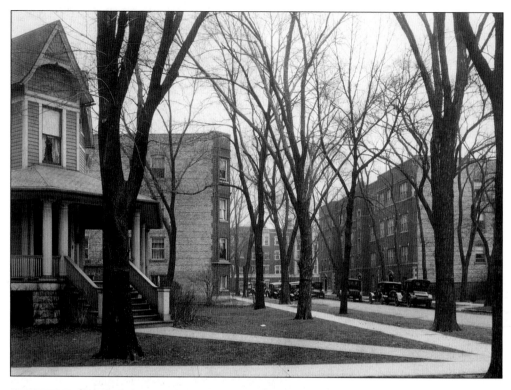

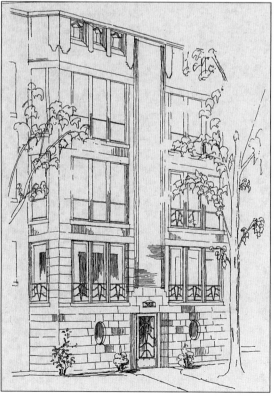

Many scores of 19th-century homes were demolished in the 1920s to clear the way for modern flats. This house (left), 300 North Grove Street, was razed shortly after this view was made in 1927 so the building below could be erected.

The Erie and Grove Apartments, 300–304 North Grove Street, was designed by E.E. Roberts with his son Elmer. Finished in 1929, it's one of the few Art Deco buildings in the village and has been designated an Oak Park Landmark. Note the geometric motifs in the decorative ironwork.

The house at 413 Wisconsin might be Victorian in style but this modern young 1920s couple appears focused on the future. During this decade, Oak Park experienced unprecedented boom and expansion. Although many homes in this vicinity were leveled, this house is still standing.

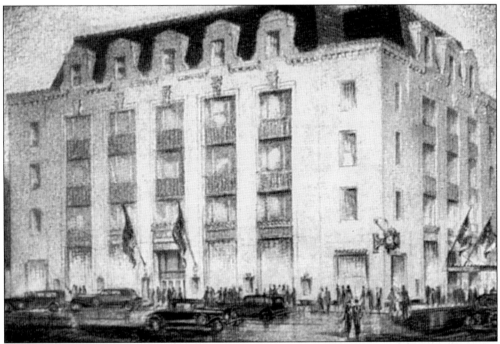

A throng of 40,000 shoppers jammed Marshall Field & Company, 1144 Lake Street, during its opening weekend in October 1929. The stylish store symbolized the growing economic supremacy of the Oak Park shopping district. Later that week, the stock market crash ushered in the decade-long Great Depression.

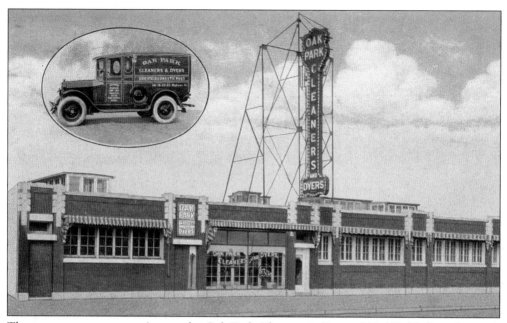

The terra cotta ornamentation on the Oak Park Cleaners & Dyers, 116-122 Madison Street, is reminiscent of Louis Sullivan's designs. The building, facing village hall, is now Easter Seal Home Bound Industries.

In 1923, Ted Carleton, age seven, had his photo taken for a postcard by an itinerant photographer on the northeast corner of Lake Street and Forest Avenue. The Methodist church that had stood there burned down earlier that year. The church was rebuilt at Oak Park Avenue and Superior Street in 1925. A pancake house now stands on the prairie setting of this view.

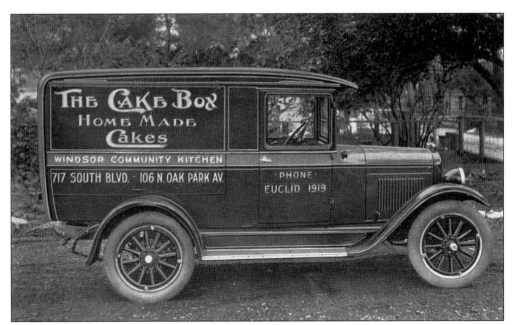

The Cake Box became so popular that two locations opened in the late 1920s. Decorated cakes for all occasions "delivered to your door" were their specialty.

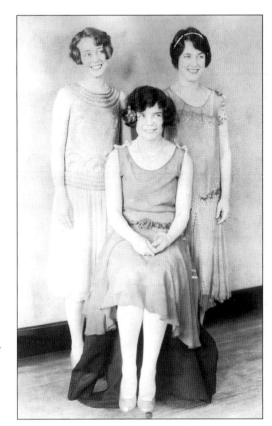

Hemlines were on the rise during the 1920s. These three seniors at Oak Park High posed for a snapshot postcard taken by a male classmate in 1927. The two girls standing are wearing typical Jazz Age drop-waist frocks decorated with intricate beading in Art Deco patterns.

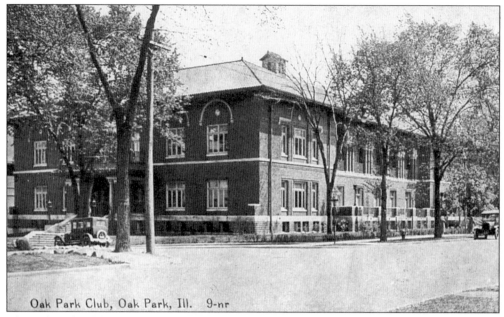

Oak Park Club, Oak Park, Ill. 9-nr

The Oak Park Club, 721 Ontario Street at Oak Park Avenue, was constructed in 1923. Everyone was required to be formally dressed, even for lunch. There was a swimming pool in the basement, as well as bowling alleys, billiard rooms, and handball courts. Young villagers learned ballroom dancing in classes conducted from October to April. In 1988, the building was converted into upscale condominiums.

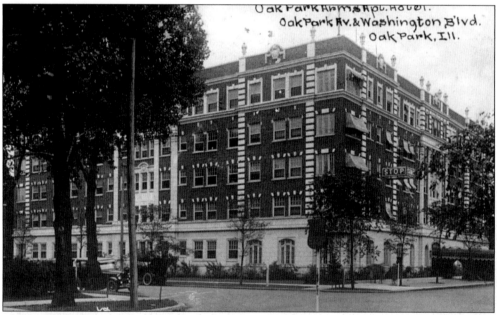

The Oak Park Arms, 408 South Oak Park Avenue, was completed in 1921. It contained a beauty parlor, a barbershop, and a restaurant. During the Jazz Age, the hotel had its own radio station, WTAY, which was widely listened to for its ballroom broadcasts of live band music. Today, the Arms is a retirement community.

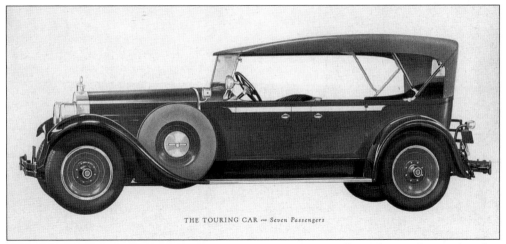

THE TOURING CAR — Seven Passengers

During the 1920s, most Madison Street ("Motor Row") dealers offered the installment plan, thus putting auto ownership within the reach of virtually every family. But while a 1927 Model T Ford was priced at $290, this seven-passenger luxury vehicle, a 1927 Packard Touring Car, cost $4,050 at Hill Motors, 640 Madison Street. The Packard was known as "the American Rolls-Royce."

According to the caption on this 1929 postcard, the Art Deco–style Swain Beauty Parlor, 130 North Oak Park Avenue, offered the latest "electrified permanent wave process."

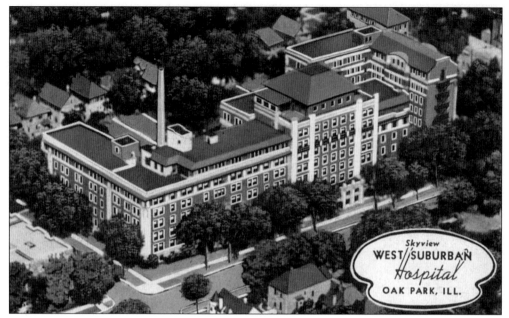

This 1930s bird's-eye view shows West Suburban Hospital, 518 North Austin Boulevard, constructed in 1914, which was added onto several times during the next couple decades. "West Sub" was Oak Park's largest employer.

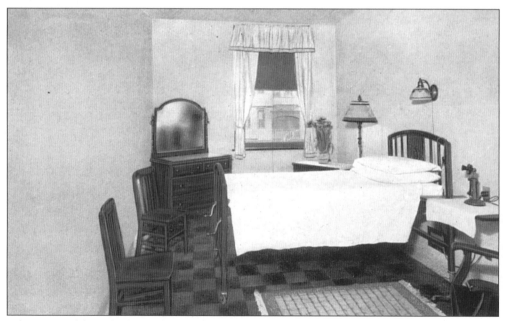

This postcard from the late 1920s shows a state-of-the-art patient room at "West Sub," complete with its own candlestick telephone.

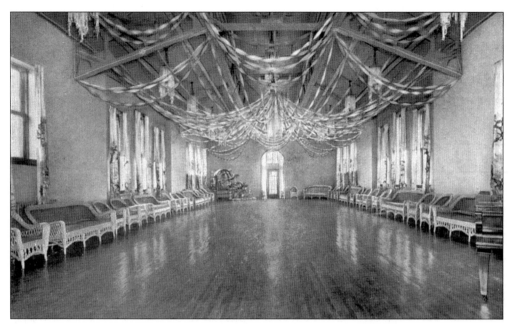

The nurses' ballroom, filled with wicker furniture, appears to be decorated for some special event, *c.* 1928.

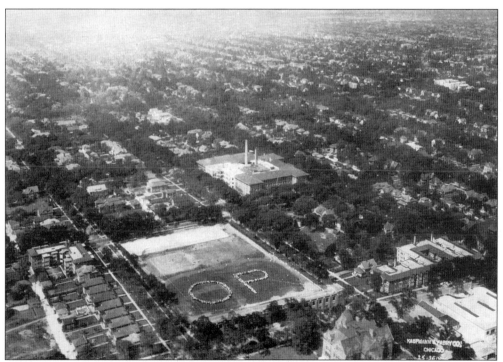

When this aerial view was taken of Oak Park and River Forest High School in 1926, the newest section of the school had not yet been completely roofed. Much of the property seen here would eventually be purchased by the high school.

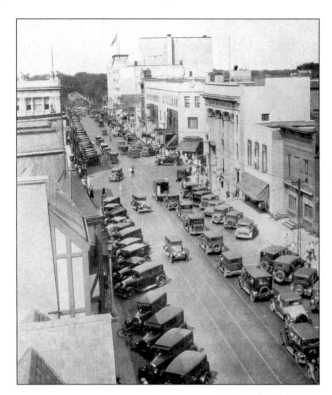

Though the Great Depression was deepening, this 1931 view of Lake Street looking west shows plenty of shoppers and auto traffic. Downtown Oak Park would be recognized as a regional shopping hub for the next four decades.

The Walker Company, 126 North Oak Park Avenue, was a popular hardware company for five decades. This advertising postcard shows the latest 1932 Model 50 Grunow refrigerator with a state-of-the-art ice cube maker. The $149.50 price tag probably made this appliance a "big ticket" expenditure out of reach for most families that year.

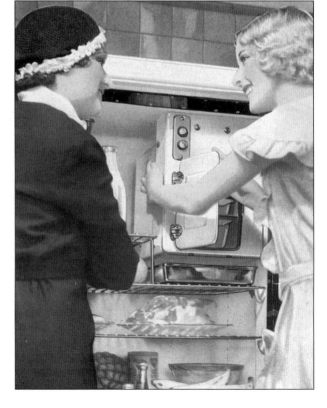

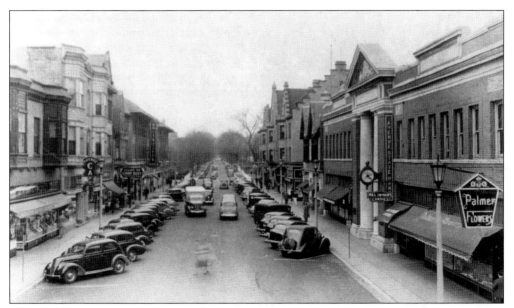

This 1938 view shows busy Oak Park Avenue looking north from North Boulevard. The trees seen in early 1900s postcards are gone. The Avenue State Bank (right) was erected on the site of the old water works and water tower.

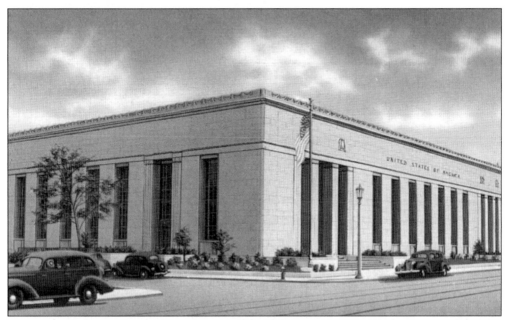

During the late 1930s, there were numerous postcards of the main Oak Park Post Office, 901 West Lake Street, which was designed by local architect Charles White, a former Frank Lloyd Wright apprentice. Often identified as Federal Art Deco, its sleek façade also exhibits classical accents. Completed in 1936, the interior contains murals by WPA artist Theodore Johnson.

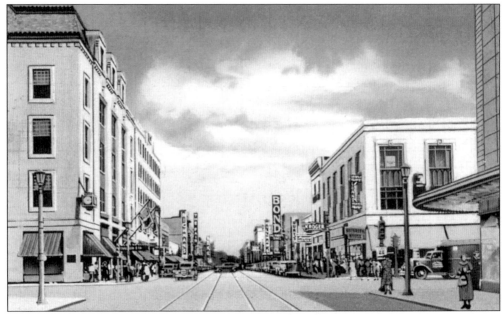

Though the depression had not fully lifted by 1938, when this postcard was mailed, the downtown business district was thriving. Oak Park had one store for every 77 residents. Looking east on Lake Street at Harlem Avenue, we note Marshall Field's (left) with its signature clock, streetcar tracks, and the edge of the new Art Deco-style Wieboldt's Department Store (right).

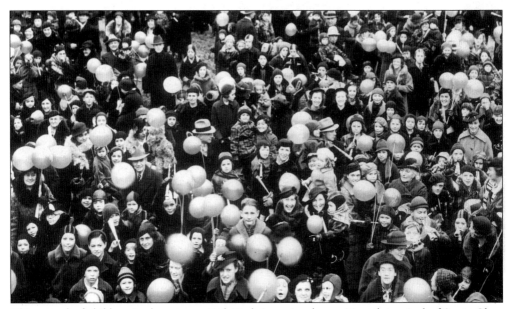

This crowd of children in downtown Oak Park is anxiously awaiting the arrival of Santa Claus at the start of the holiday shopping season in 1936.

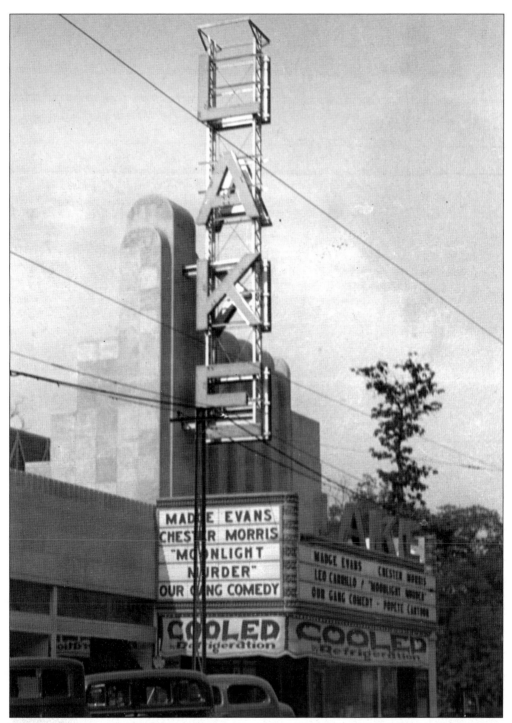

The new Art Deco-style Lake Theater was one of few air-conditioned buildings in the village in 1936. *Moonlight Murder*, a backstage whodunit set in an opera company, was playing with an "Our Gang" short and a Popeye cartoon. Ladies were given free dinnerware on Tuesdays and Thursdays ("Dish Nights").

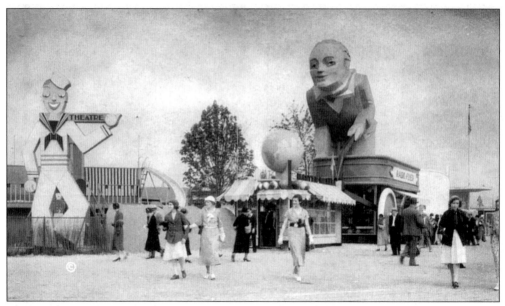

Josephine Blackstock (1887-1956), the founding director of playgrounds in Oak Park, was not only a well-known children's author but was considered the most outstanding woman in recreation in the nation. She brought Oak Park special fame when she created the "Enchanted Island" for the 1933-1934 "Century of Progress" World's Fair in Chicago.

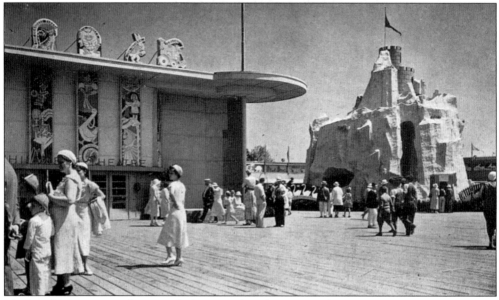

Blackstock's innovative theme park design at the Chicago World's Fair pushed the envelope for such large-scale fantasy playgrounds decades before Disneyland.

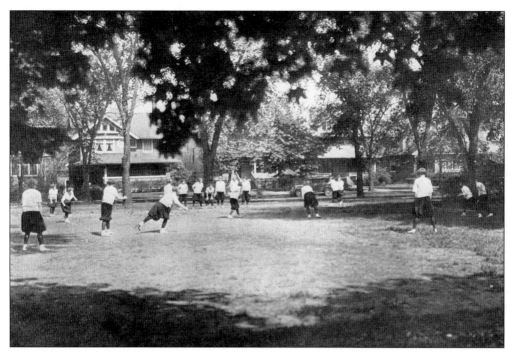

By 1926, high school girls were encouraged to become more active. These young ladies, clad in bloomers, middy-blouses, and black lisle stockings, are playing baseball.

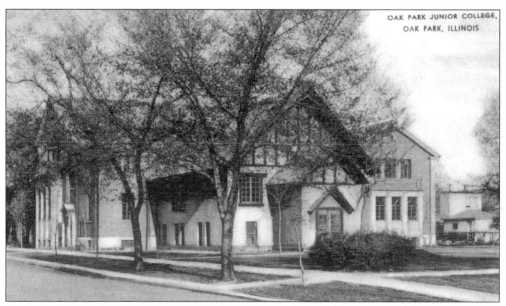

Housed in the old North Congregational Church building for six years during the Great Depression, Oak Park Junior College, 255 Augusta Avenue, offered over 50 liberal arts courses. During 1936-1937, 143 students were instructed by 12 faculty members. Tuition was $65 per year. Since 1940, the Dole Branch of the Oak Park Public Library has occupied this building, which was renovated in 2002.

This 1940 postcard was mailed out in bulk in an attempt to convince villagers to vote "yes" on a library referendum. Oak Parkers voted the proposal down. A new library would be erected during the 1960s, but not this one.

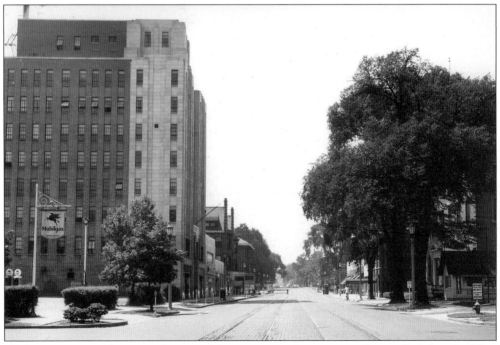

Looking west on Lake Street from Euclid Avenue in 1947, we see the Medical Arts Building (left), 715 Lake. This 1929 Art Deco-style mini-skyscraper, designed by local architect Roy Hotchkiss, cost $250,000.

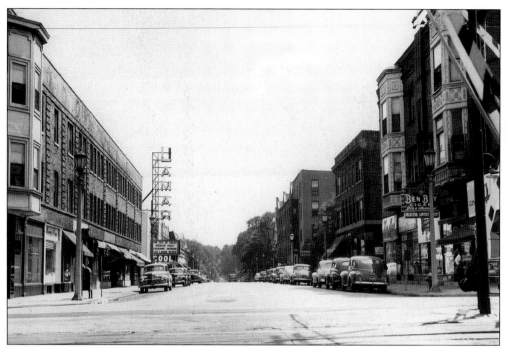

Looking south from the street-level elevated tracks and crossing gates in 1947, we can see the Lamar Theater on the left. Its name was an abbreviation of the El stop—Lake/Marion. The movie house, which opened as the Oak Park Theater in 1913, was razed in the 1980s.

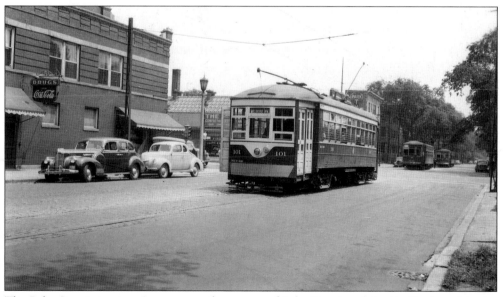

The Lake Street streetcar is seen near the corner of Lake Street and Austin Boulevard in the mid-1940s.

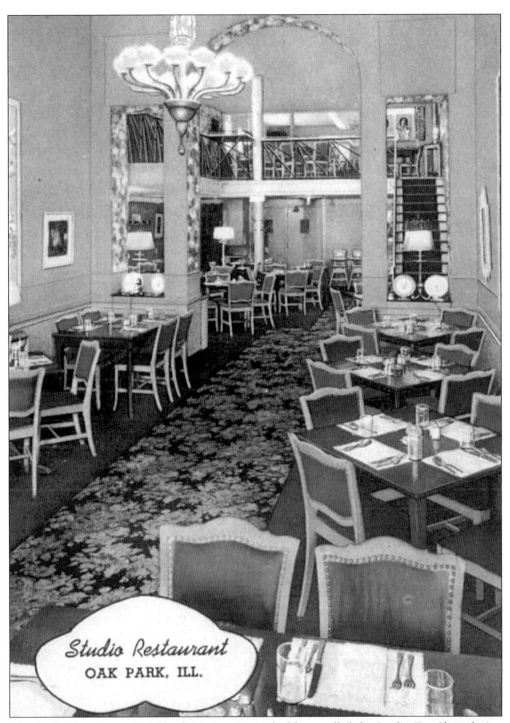

Studio Restaurant
OAK PARK, ILL.

The Studio Restaurant, 114 North Marion Street, had been called the Studio Tea Shop during the lean 1930s. But by the time this postcard was sent in 1948, increasing numbers of shoppers enjoyed dining downtown. This air-conditioned eatery, decorated in royal blue, featured daily blue plate specials. A beauty salon now occupies this location.

Typical of the new chain businesses coming into downtown Oak Park at mid-century was the California Brick Kitchen, 419 North Harlem Avenue, "famous from Coast to Coast for Spare Ribs". This postcard features a calendar for 1948. A blurb on the backside brags about the "golden brown southern fried chicken."

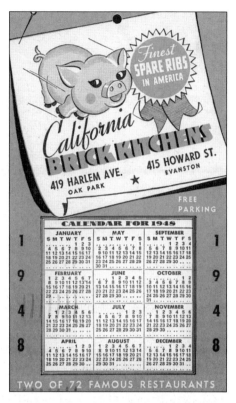

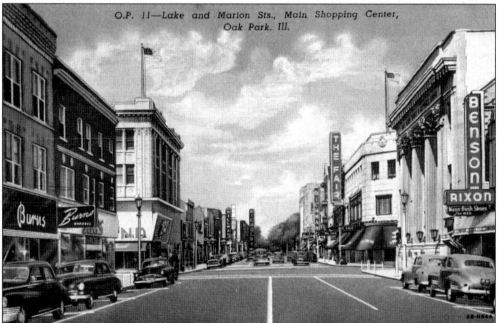

Looking west on Lake Street in 1949, we see downtown Oak Park when it was one of the busiest shopping centers in the region. Note the Fair, northwest corner of Lake Street and Marion Street, one of the many large chains along the strip.

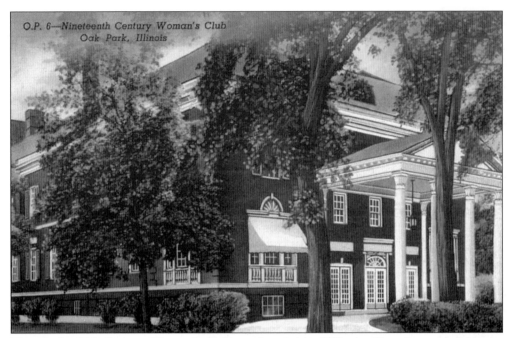

Though the 19th-Century Women's Club was founded in 1890, the Georgian-style clubhouse building, 178 Forest Avenue, was not erected until 1927. It was considered one of the show places in Oak Park, as can be seen in this 1940s postcard. There was a large swimming pool in the lower level. Guest lecturers included such notables as Jane Addams, Pearl Buck, Paul Robeson, and Carl Sandburg.

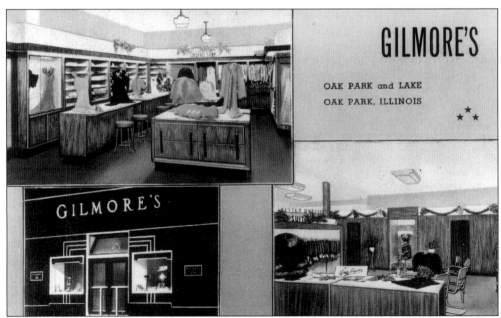

This 1946 postcard shows Wm. Y. Gilmore & Sons, 151 North Oak Park Avenue. Like the big Loop department stores, Gilmore's likened itself to a women's clubhouse, offering such amenities as a beauty salon, a tearoom, on-site milliners, and seamstresses, plus charge accounts.

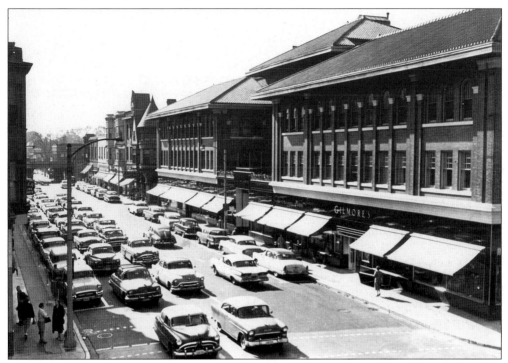

This mid-1950s view of Gilmore's, situated for six decades in E.E. Roberts' Scoville Masonic Block, illustrates how traffic had increased by mid-century.

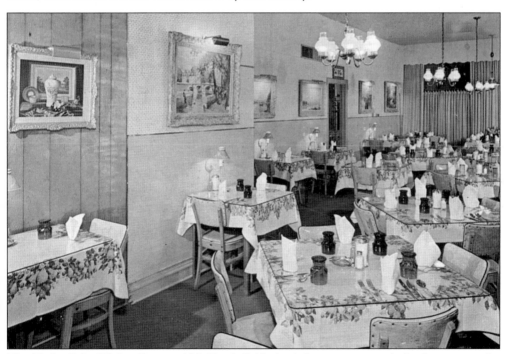

The Twin Oaks Dining Room, 134 North Ridgeland Avenue, was typical of many popular restaurants in the village during the late 1950s.

This 1940 aerial view of south central Oak Park shows the Oak Park Avenue and Harrison Street business district just north of the street-level trains and El tracks. Two decades later, the Eisenhower Expressway was under construction.

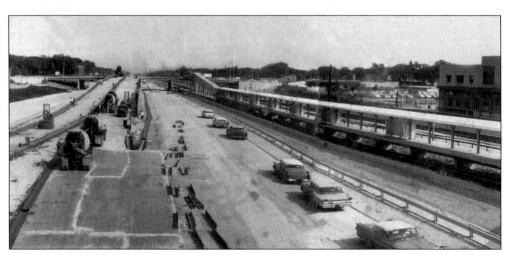

As the massive Eisenhower Expressway project neared completion in 1959, many workers began to park their cars on the unopened stretch of highway.

Five

CHURCH BELLS AND SCHOOL BELLS

Religious organizations built so many churches in early Oak Park that the village became known as "Saints' Rest." The tall steeples of many of these structures served as landmarks visible for many miles around.

Churches played a key role in the lives of Oak Parkers. They especially provided significant social outlets for people during the early 20th century.

Celebrated Oak Park theologian Dr. William Barton (1861–1930) once recalled two teamsters hauling building material out to Oak Park from the city.

The first driver shouted to the man driving the wagon behind him, "How shall I know when we're in Oak Park?"

The second teamster replied, "You'll know you're in Oak Park when the saloons stop and the church steeples begin!"

Confident, optimistic Oak Parkers knew their village had everything, but they were especially proud of its progressive schools.

During the golden age of the picture postcard, there were literally scores of images of Oak Park's fine schools and photogenic churches in circulation. Fortunately, many of these images have survived to provide us with a glimpse back at the stunning architecture of these buildings.

This 1908 montage postcard celebrates the pride Oak Parkers felt for their many photogenic churches. Frank Lloyd Wright's new Unity Temple (middle right) was recognized for its unorthodox form and materials.

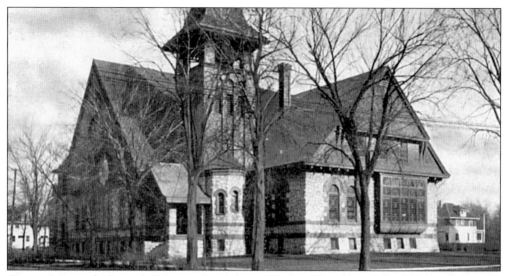

Queen Anne-style Second Congregational (now Pilgrim Church) at Lake Street and Scoville Avenue, was built on land donated by James Scoville in 1889. The homes seen in the background were razed in 1907 to clear room for the high school.

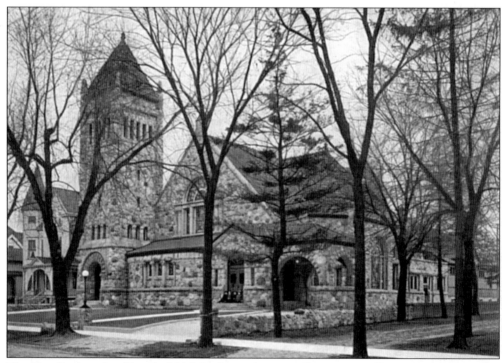

The First Presbyterian Church, 931 Lake Street, is a stone Romanesque/Byzantine structure that cost $60,000 and took a year to construct in 1901. The building was sold in 1978 to the Calvary Memorial congregation.

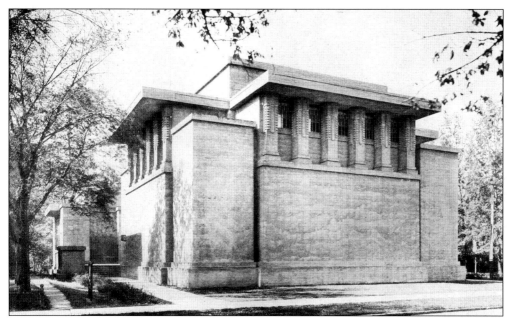

Unity Temple, 875 Lake Street, Frank Lloyd Wright's "concrete monolith," was not yet completed when this postcard was mailed in 1908. After their Gothic Revival church was struck by lightning and destroyed by fire, the congregation asked Wright to design their new building on a modest budget of only $45,000. The resulting reinforced, poured concrete structure, which contains no traditional religious symbols, came as quite a shock to the congregation.

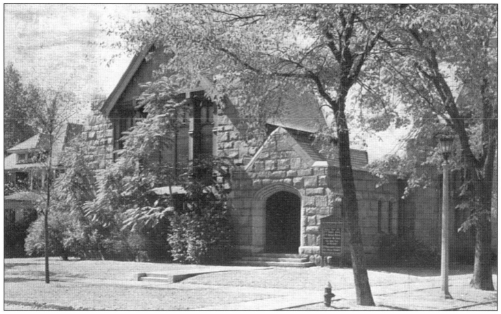

Cuyler Avenue Methodist Church, 171 North Cuyler at Ontario Street, was founded in 1900 but the building was not completed until 1914. Constructed of rough-hewn red granite, this house of worship is now known as Cornerstone United Methodist Church.

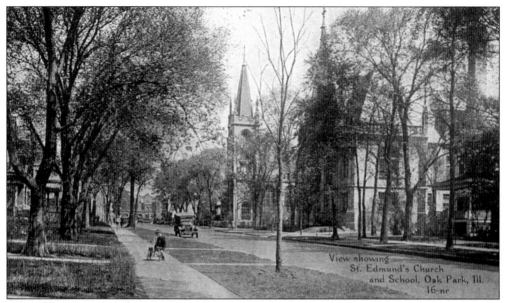

St. Edmund's, 188 South Oak Park Avenue, was Oak Park's first Catholic church. When the parish's founder, Father John Code, first arrived in the village in 1907, religious intolerance forced him to say Mass in an abandoned barn on the Scoville property. The 14th-century English Gothic Revival church, seen here in 1928, cost $60,000 in 1910. By the time he died at age 88 in 1956, Monsignor Code had served 49 years in the parish.

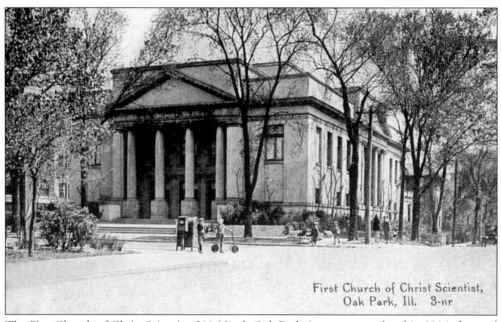

The First Church of Christ Scientist, 200 North Oak Park Avenue, completed in 1916, featured such Classical Revival features as Roman columns and pediments. The building operated as a church until 1988. Now it is an arts center and performance space.

The Gothic-style First Congregational Church, 848 Lake Street, situated on a lot donated by James Scoville, is seen here in a 1906 view. Ernest Hemingway's family worshiped here. The church burned down in 1916 when lightning struck the 190-foot Gothic steeple.

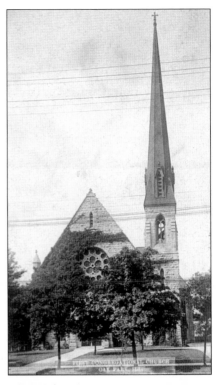

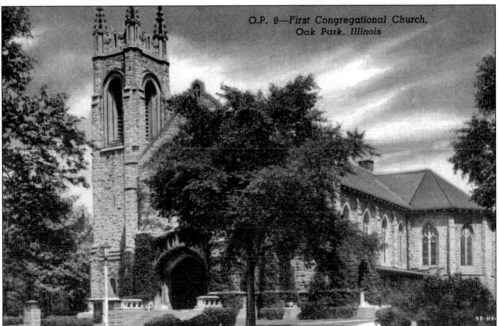

The new First Congregational building (1917) incorporated many of the stones saved from the original church (above). The style was a combination of English and French medieval designs with a lower, square Norman tower. In 1975, the church merged with First Presbyterian to become First United Church.

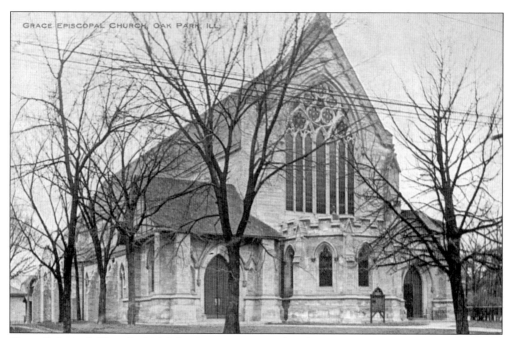

Grace Episcopal Church, 924 Lake Street, was completed in 1901 in the 14th-century English Gothic Revival style. It replaced an earlier structure at 210 Forest Avenue—which became the site of Frank Lloyd Wright's Frank W. Thomas house (1901).

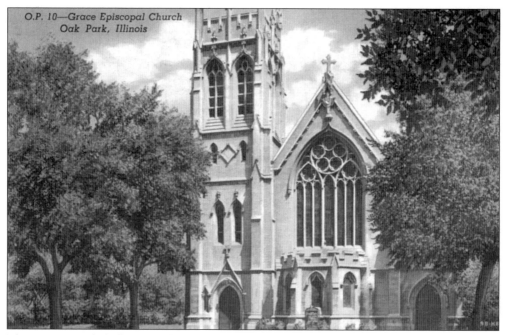

The Norman style bell tower of Grace Episcopal was dedicated in 1922, over two decades after the rest of the church was built. This house of worship has been the location for two movies: Robert Altman's *A Wedding* (1978) and *Home Alone* (1990).

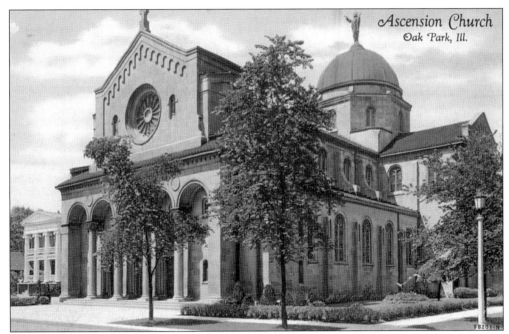

Ascension Roman Catholic Church, 915 South East Avenue, was built in 1912 in the Romanesque style. The famous 32-foot diameter dome, which rises 100 feet, is crowned by a 15-foot solid bronze statue of the Ascension of Christ.

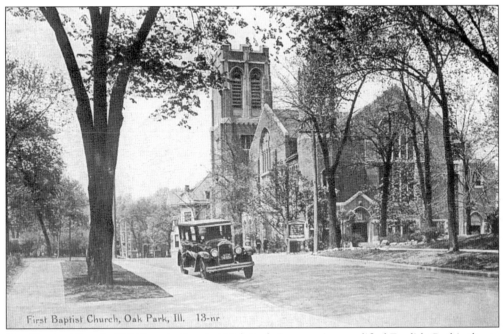

First Baptist Church, 920 Ontario Street at Oak Park Avenue, is a modified English Gothic three-story structure designed by E.E. Roberts. Though the building was constructed in 1923, the roots of this congregation go back to 1873.

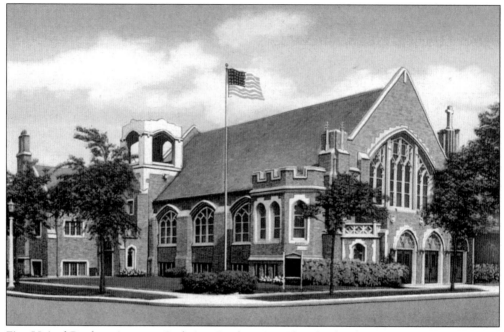

First United Presbyterian, now Parkview Presbyterian Church of Oak Park, 641 South Oak Park Avenue at Jackson Boulevard, was dedicated in 1925.

One of the newest houses of worship in Oak Park, Good Shepherd Lutheran Church, 611 Randolph Street, was erected in 1941. Its red brick, Colonial Williamsburg style, with classical portico and square central tower, makes it unique in the village.

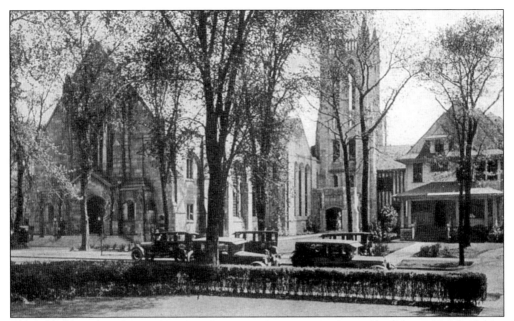

The First Methodist Church was located at the northeast corner of Lake Street and Forest Avenue until it burned down in 1923. The new Gothic style house of worship at 324 North Oak Park Avenue was completed in 1925.

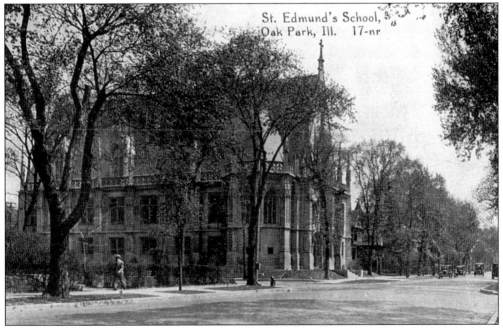

St. Edmund's School, 208 South Oak Park Avenue, was constructed in 1917. Its French Gothic Revival design was modeled after the Palais du Justice in Rouen, France. A four-foot-high perforated railing encircles the top of the building just below the roof.

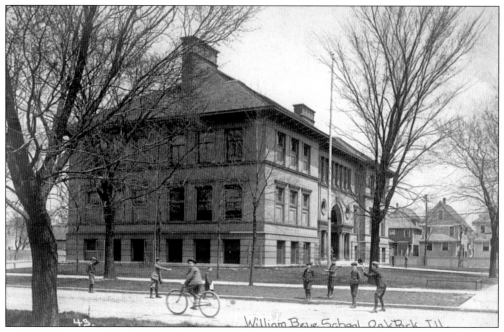

William Beye School, 230 Ontario Street, was built in 1896 at a cost of $26,448.60. Beye, a beloved, recently deceased school board treasurer, had been instrumental in adding the fine arts to Oak Park Schools.

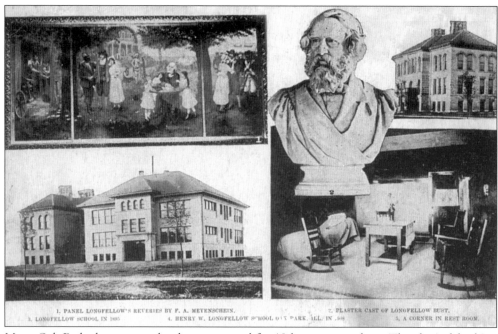

1. PANEL LONGFELLOW'S REVERIES BY F. A. MEYENSCHEIN.
2. PLASTER CAST OF LONGFELLOW BUST.
3. LONGFELLOW SCHOOL IN 1895 4. HENRY W. LONGFELLOW SCHOOL OAK PARK. ILL. IN 1898 5. A CORNER IN REST ROOM.

Many Oak Park elementary schools were named for 19th-century authors. The classical-looking bust is poet Henry W. Longfellow. When this postcard was mailed in 1908, pupils at Longfellow School, 315 Jackson Boulevard, learned the four R's: reading, 'riting, 'rithmetic, and recitation.

112

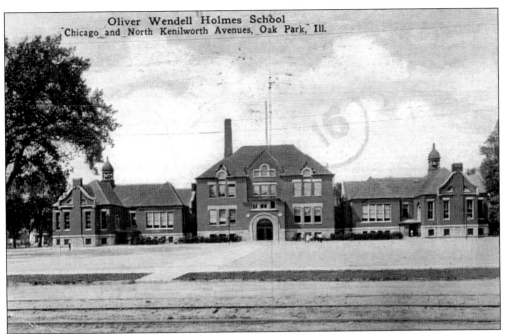

Oliver Wendell Holmes School
Chicago and North Kenilworth Avenues, Oak Park, Ill.

Many of the Oak Park elementary schools in the early 1900s were often referred to as collections of brick cottages or small buildings joined together, as can be seen in this 1907 postcard of Oliver Wendell Holmes School, 500 North Kenilworth Avenue. Ernest Hemingway and some of Frank Lloyd Wright's children were pupils here at the time. This school was razed in the 1950s to make way for the current structure.

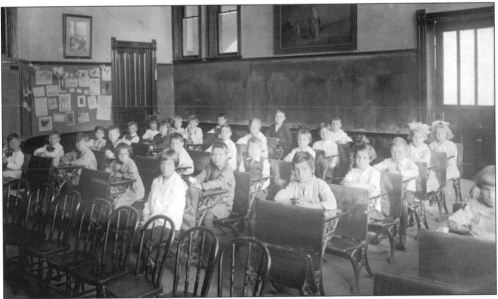

School was conducted in a formal atmosphere when this postcard photo was taken of one of the lower grades at Holmes School in 1915. Lessons consisted primarily of copying, memorization, and recitation.

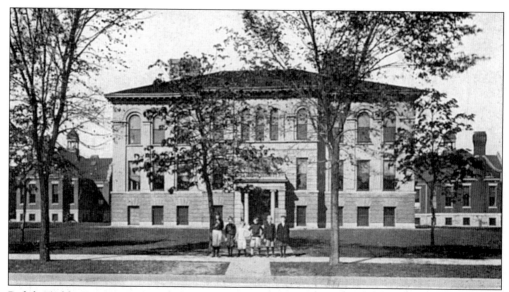

Ralph Waldo Emerson School, 900 Washington Boulevard, has been rebuilt several times since this postcard was mailed in 1908. In 2002, an entirely new building opened on this location called Gwendolyn Brooks Middle School.

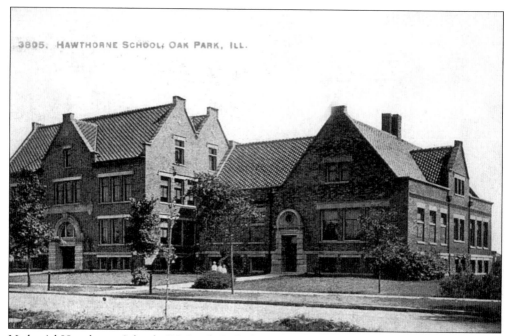

Nathaniel Hawthorne School, 420 South Ridgeland Avenue, seen in this 1910 postcard, was also remodeled and rebuilt several times until it was razed in 2002. Percy Julian Middle School now stands on this site. Oak Parker Julian (1899–1975) was an African-American chemist and inventor.

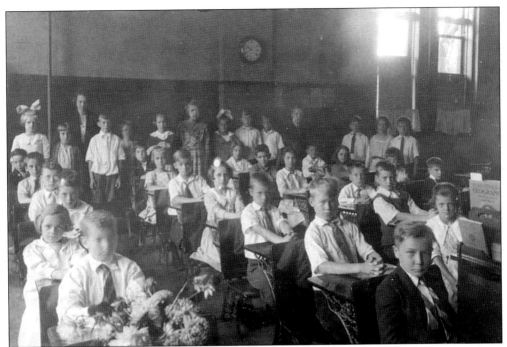

Clanging bells literally summoned Oak Park children to school in the 1920s. This postcard from Washington Irving School shows that elementary pupils dressed more formally back then. Note the boys wearing neckties.

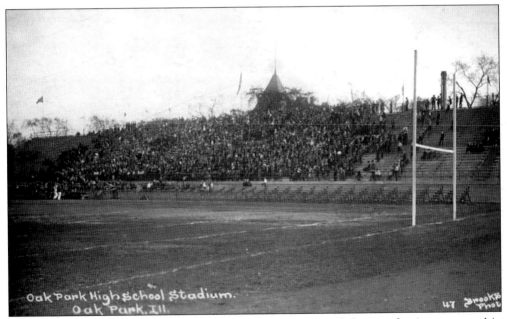

This postcard of the new high school football stadium was mailed soon after it was erected in 1924. There was yet no press box. The tall roof seen just beyond the top row of seats belongs to the old high school on Lake Street.

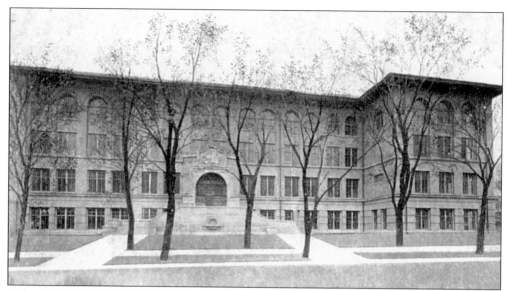

Although Oak Park High School was often described as Italian Renaissance style, the building had a decidedly Prairie School look as well. The new structure was finished in time to start the 1907–1908 school year.

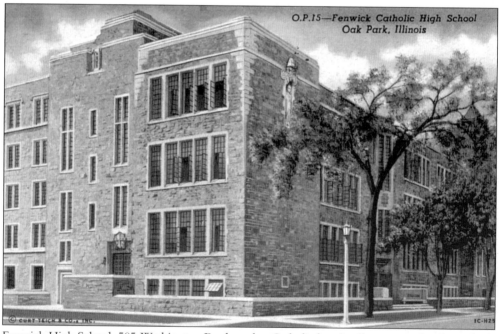

O.P.15—Fenwick Catholic High School
Oak Park, Illinois

Fenwick High School, 505 Washington Boulevard, a Catholic boys' college prep school, was built in 1928–1929. The three-story, block-long English Gothic-style structure was initially called the Dominican High School but was soon named for Edward Dominic Fenwick, the friar who established the Dominican order in the U.S. By the time this postcard was mailed in 1937, Fenwick had an enrollment of 500 students and a 30-member faculty. The school became co-ed in the 1990s.

LOST OAK PARK

People often think that since Oak Park is a historic community it probably looks much like it did a century ago. Actually, although many venerated landmark structures survive, countless early buildings vanished long ago.

Bordered on all four sides by other municipalities, the rectangular, 4.5 square mile village of Oak Park was virtually all "built up" by the time World War II began. Since there was no room for further expansion without knocking something down, buildings believed to be useless, obsolete, or "in the way" were quickly demolished and replaced.

Thus, much of early Oak Park disappeared. Very few pioneer homes or businesses remain. Many scores of 19th-century structures were razed during the apartment boom and commercial prosperity of the 1920s, as well as the periodic expansions of Oak Park schools and institutions.

Surely, of course, not everything that has been torn down was architecturally or historically significant. Sometimes a loss was just a diner or a dime store, a "bus barn," or a beauty parlor. But fortunately for us, with old-time postcards we can revisit many of the places that have fallen in the path of the wrecker's ball to make way for the march of progress in Oak Park.

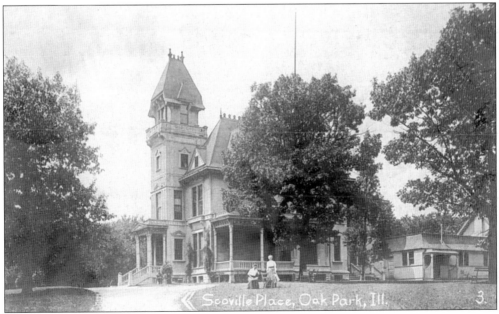

James Scoville's 23-room 1880 elaborate Victorian mansion stood at the top of the hill at Lake Street and Oak Park Avenue. In 1912, the property was purchased by the newly formed Oak Park Park District. After the house was demolished, the 4.5-acre site was laid out by Jens Jensen, internationally known landscape artist.

During the early 1920s, as the Oak Park Avenue business district extended south of the railroad tracks, this block (seen in a 1907 view) was completely razed and developed as a commercial strip. The tall house on the left, 185 South Oak Park Avenue, was owned by Richard W. Sears (1863–1914), founder of Sears, Roebuck & Company.

Henry W. Austin Sr. (1828–1889), banker and temperance advocate who personally closed down all Oak Park saloons, lived in this steep-roofed home, which faced Lake Street. During the mid-1930s, the front yard of the Austin estate was sold off and developed for businesses, including the Lake Theater. The home was eventually razed in the 1960s. The rest of this yard is now Austin Gardens Park, donated by the Austin family.

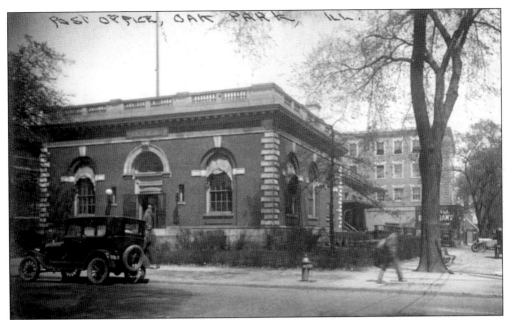

Oak Park's first substantial post office (1905), seen here in a 1920s view, was located at 144 North Oak Park Avenue at Lake Street. When the large 1936 post office was opened at Lake Street and Kenilworth Avenue, this building was demolished to make way for a commercial development. A bread store now stands on this site.

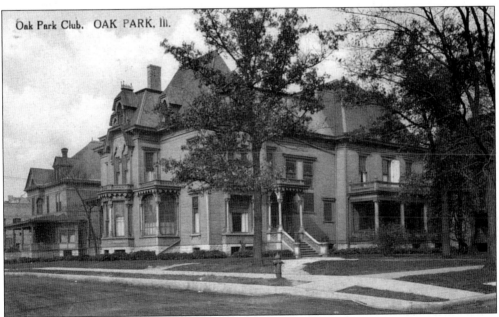

The Oak Park Club, a social club for the entire family, was organized in 1890 in the old S.E. Hurlbut mansion, 1010 North Boulevard. Thursday night was always the busiest evening in the dining room, as that was "maid's night off" in Oak Park. The old home burned down in 1920. The rest of the block was razed and replaced with a series of combination retail and apartment courtyard buildings in 1929.

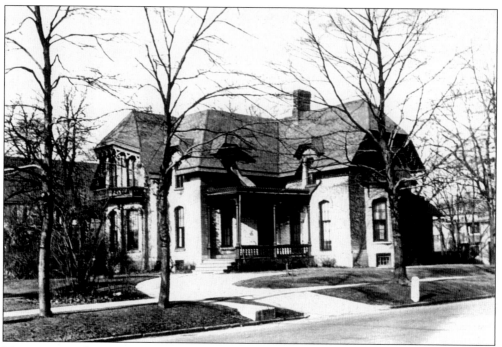

Many scores of Victorian homes were demolished to make way for progress. The Gothic Revival-style Gale house, designed in 1867 by W.W. Boyington, architect of Chicago's famous Water Tower, stood on the northwest corner of Lake Street and Kenilworth Avenue until the 1960s, when it was razed and replaced with a large apartment complex.

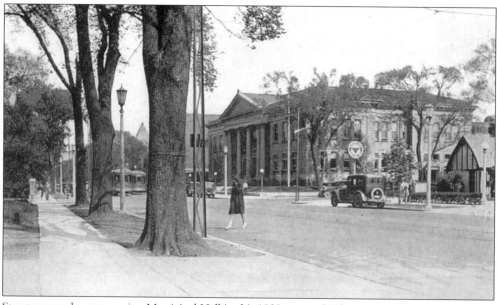

Streetcars can be seen passing Municipal Hall in this 1929 postcard. The view looks east toward Lake Street and Euclid Avenue. E.E. Roberts' 1904 building, which remained in use for eight decades, was demolished in 1975. A modern Prairie-style apartment complex now stands on the site.

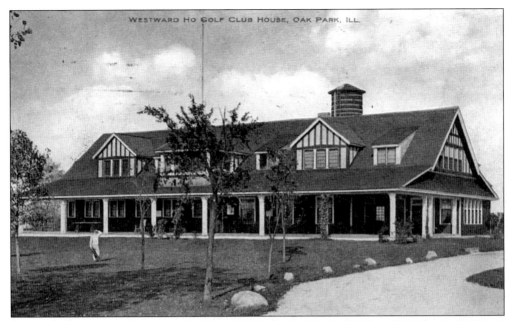

Postmarked in 1911, this postcard shows the Westward Ho Golf Club, Ridgeland and North Avenues. Golf boomed in popularity when overweight-President William Taft took up the game for his health. After a disastrous fire, the club was never rebuilt. By then real estate had become too valuable in north Oak Park.

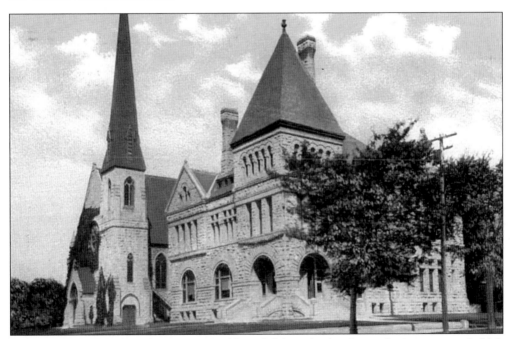

Oak Parkers of the early 20th century joined lots of clubs and cultural organizations, many of which met in the Scoville Institute. This Romanesque 1888 library, 834 Lake, was razed in 1961 and replaced. The 1960s library was demolished in 2002. A third structure was erected here in 2003. The church on the left is First Congregational.

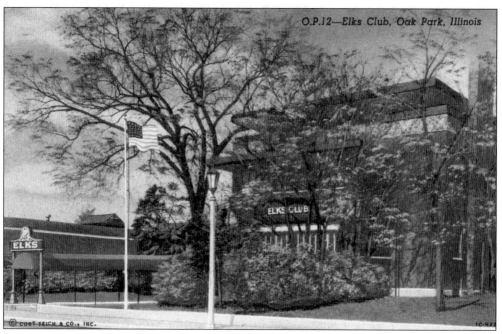

Seen here in a postcard view postmarked 1949, E.E. Roberts' Prairie-style, three-story Elks Lodge, 938 Lake Street, was torn down in the mid-1970s. A parking garage now stands on the site.

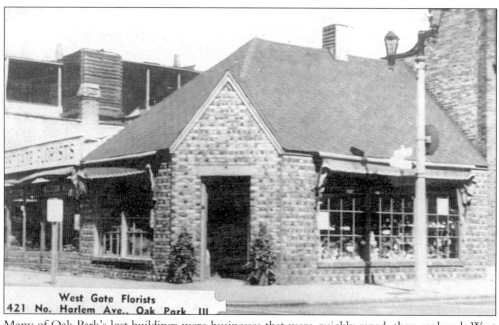

Many of Oak Park's lost buildings were businesses that were quickly razed, then replaced. West Gate Florist, 421 North Harlem Avenue at Westgate Street, was a rustic stone structure open from the early 1930s through the mid-1950s.

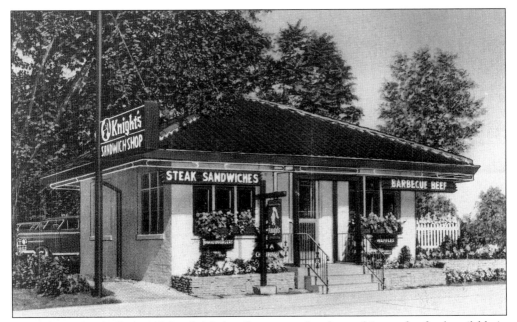

Knight's Sandwich Shop, 113 South Marion Street, was the closest thing to fast food available in 1940s Oak Park. Though this 1949 postcard makes the location appear rural, the diner was just a half block south of the El tracks. An office building now sits on this site.

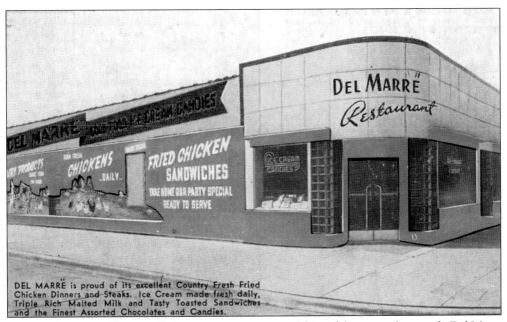

Chicken dinners and homemade ice cream were two specialties of the art moderne-style Del Marre Restaurant of the late 1930s, located on the southwest corner of Ridgeland Avenue and Harrison Street. The caption on the back boasted the Del Marre was "one of the Show Places of Oak Park."

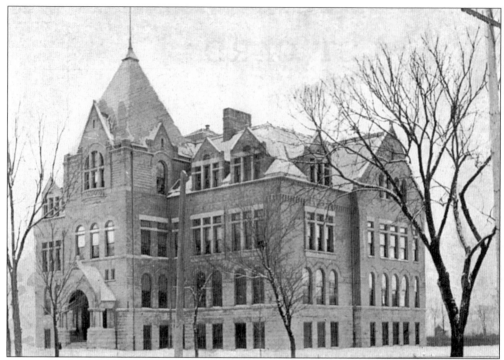

Oak Park's first high school building at Lake Street and East Avenue opened in 1891. But as the population boomed in the next decade, by 1903, the school was so overcrowded that 515 pupils occupied the building designed for 350. From 1916 through 1969, the structure housed a Catholic military boarding school called Bishop Quarter. A townhouse development now stands on this site.

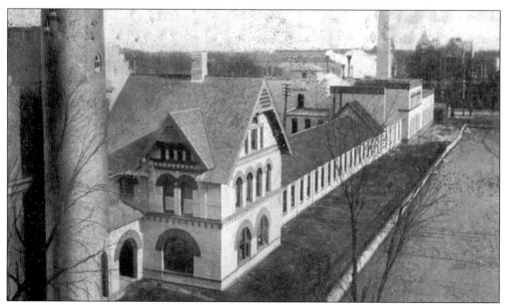

Local legend has it that Ernest Hemingway and his adolescent chums dumped fish and swam in the Oak Park reservoir's big pond. By 1920, when the village was pumping in water from Lake Michigan, this Oak Park Avenue site was developed for a bank.

Seen here in a view postmarked 1908 is the Nathan Moore home, 333 Forest Avenue, one of Frank Lloyd Wright's most atypical designs. The Tudor Revival house was destroyed by fire during Christmas 1922. The old coachhouse remains in the alley.

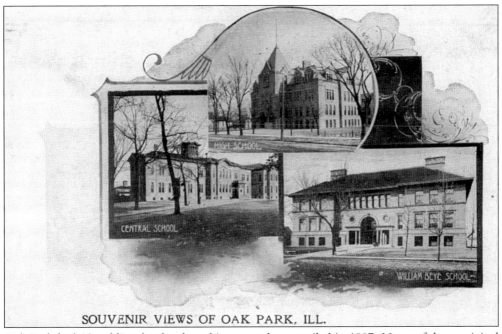

SOUVENIR VIEWS OF OAK PARK, ILL.

Oak Park had 12 public schools when this postcard was mailed in 1907. None of those original buildings still exist.

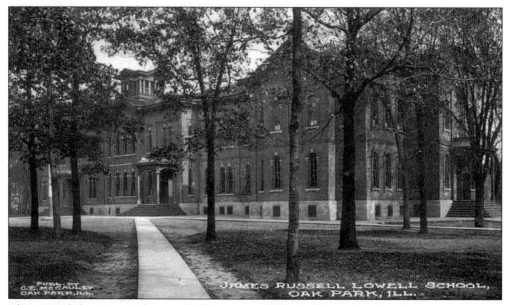

The original three units of Central School, Lake Street and Forest Avenue, were built in 1859, 1874, and 1880. All 12 grades were housed here before Oak Park had a high school. The bell in the belfry was used daily. When the middle section burned in 1924, eleven new rooms and a gymnasium were added and the school was renamed James Russell Lowell School. In 1986, 100 Forest Place, a high-rise apartment development, was erected on this site.

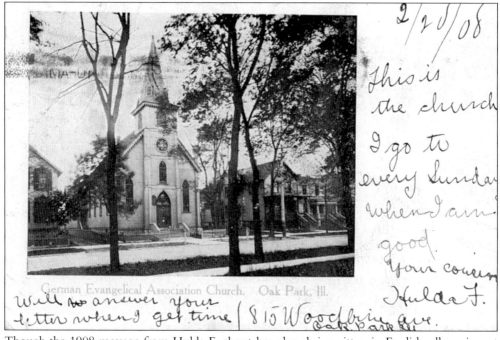

Though the 1908 message from Hulda F. about her church is written in English, all services at the German Evangelical Association Church, 1107 Ontario Street, were conducted in German. The structure, built in 1867, was demolished in the 1950s.

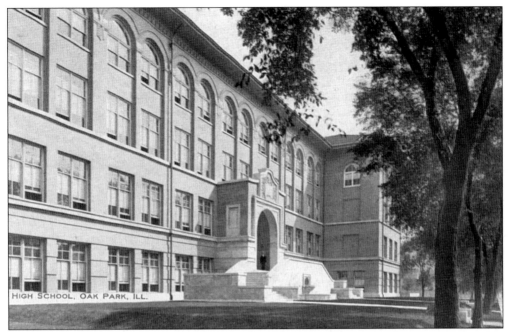

The beloved arched entrance to Oak Park High is seen on a 1915 postcard. During an ambitious late-1960s construction program, the school was extended across Ontario Street to connect the academic building with the physical education facilities. The main entrance was then relocated on Scoville Avenue.

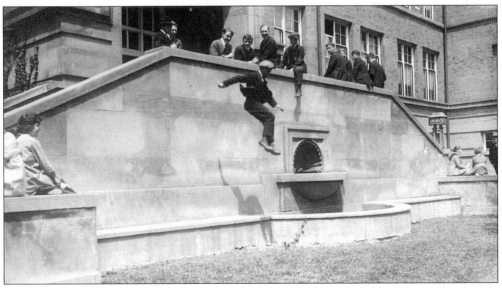

The girls on the left look on while male classmates engage in a bit of horseplay at the Ontario Street entrance in 1916. Ernest Hemingway was a junior at the time. Boys wore jackets and ties to class. This famed arched entrance stood where the Little Theater is now located inside the newest section of the school.

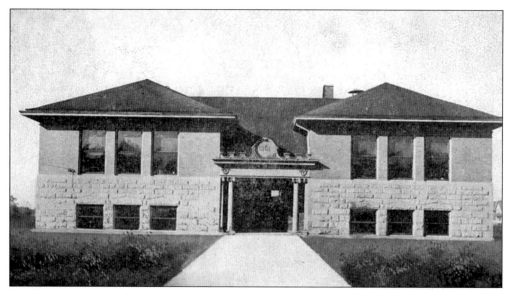

This 1907 postcard shows the first Whittier School, designed by E.E. Roberts. Note the combination of Prairie School style with classical symmetry and ornamentation, especially the Ionic columns.

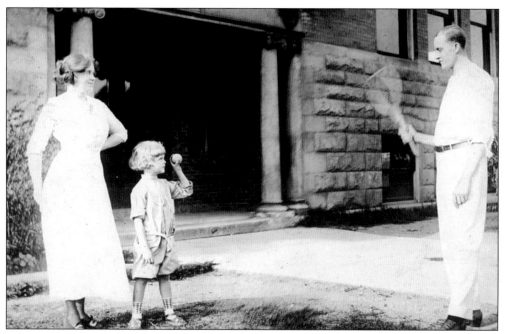

This amateur trick photography postcard from 1918 was shot in front of Whittier School. A camera on a tripod was partially masked so that it would only photograph the left half of its image. Frank (right) first snapped a shot of his wife Josephine and daughter, then rewound the film. Next Jo masked the left side of the camera, uncovered the right side, and snapped a picture of Frank. The two "halves" were thus photographed separately but combined seamlessly to make one image.